Charles Krafft

An Artist of the Right

Edited by
Greg Johnson

The Mystic Sons of Charles Krafft
2022

Copyright © 2022
All rights reserved

Cover design by Kevin I. Slaughter

Published in the United States by
The Mystic Sons of Charles Krafft

Hardcover ISBN: 978-1-64264-009-0
Paperback ISBN: 978-1-64264-010-6

Contents

Introduction by Greg Johnson ❖ iii

1. Counter-Currents Radio Interview, April 29, 2012 ❖ 1

2. A Toast & an Oath ❖ 45

3. An Artist of the Right ❖ 47

4. Counter-Currents Radio Interview, March 12, 2013 ❖ 52

5. Grace Under Pressure: Life as a Thought Criminal ❖ 85

6. A Proust Questionnaire ❖ 96

7. Counter-Currents Radio Interview, January 17, 2014 ❖ 98

8. The Handshake ❖ 126

9. The London Forum Speech ❖ 129

10. What's Wrong with the Arts? ❖ 146

Index ❖ 161

About the Author ❖ 174

Editor's Introduction[*]

> Charles Krafft is my name,
> America is my nation,
> Seattle is my dwelling place,
> And art is my salvation.

Charles Wing Krafft was a painter, porcelain artist, and provocateur. His more than fifty-year career as an artist encompassed both fine art (he was a painter of the Northwest School) and so-called "lowbrow" pop art (his world-famous ceramics). He was also a poet and essayist. Although he traveled widely, he lived most of his life in and around Seattle.

Charles Krafft—Charlie to his friends—was born in Seattle in 1947 to an upper-middle-class family. His father was a Boeing executive, his mother a housewife. He attended racially integrated public schools, which even then were rife with violence. To protect him from bullies, his parents placed him in the exclusive Lakeside School, but after three years, he flunked out and spent his last year at Roosevelt High School, from which he barely graduated in 1965. Immediately after graduating, he ran away from home, heading to the Bay Area where he stayed with his cousin Grace Slick and her husband. (Born Grace Wing, she is the daughter of Charles' mother's brother.)

At the time, Charlie wanted to be a Beatnik poet, but he realized that he could not support himself as a poet, so he tried his hand at painting and found he had a knack for it. Charlie also made money putting on psychedelic light

[*] Adapted from my obituary, "Remembering Charles Wing Krafft: September 19, 1947–June 12, 2020," *Counter-Currents*, June 17, 2020.

shows at rock concerts. After he returned home to Seattle, his parents enrolled him in Skagit Valley Community College, which he attended while continuing to paint and do light shows. After one year of college, Charlie dropped out to devote himself to art full-time.

Charlie was mostly self-taught. "The only art credentials I have are the 'astral apprenticeships' I served under the reclusive painter of startled birds, Morris Graves (1910–2001) and the crackerjack Hollywood hot rod hero, Von Dutch (1926–1992)."[1]

Charlie also benefitted from the mentorship of Northwest painter Guy Anderson (1906–1998) and learned the art of painting on porcelain from an elderly Seattle hobbyist named Barbara Henderson: My "career in clay began in a suburban breakfast nook . . . the cozy clubhouse of a gang of sable-brush-wielding grannies who call themselves the Northwest China Painters Guild."[2]

In 1968, Charlie settled in Fishtown, a group of abandoned fisherman's shacks along the Skagit River, which became an artist and hippie colony. Charlie was a central fixture of Fishtown, its unofficial mayor:

> Fishtown was a prolonged experiment in the style of deliberate simplicity celebrated by Thoreau and inspired by the example of two legendary Northwest Zen Buddhists, Morris Graves and Gary Snyder. . . . Throughout the 1970s, Fishtown existed as a year-round community and a marshy Mecca for a constant stream of nomadic young visitors from Seattle, San Francisco, and points beyond. It was one of the region's most visible symbols of the youth quake

[1] "Artist Series Post #6: Charles Krafft," *Juxtaposing*, December 13, 2010.

[2] Douglas Cruickshank, "Been there, smashed that," *Salon.com*, May 30, 2002.

that swept the country in the '60s.[3]

Early in his career, Charlie was drawn to the so-called Northwest School of painters, the principal figures of which were Kenneth Callahan (1905–1986) and Mark Tobey (1890–1976) as well as Guy Anderson and Morris Graves. Guy Anderson helped Charlie grow as an artist, but Graves was the greatest inspiration. The two became friends, and in 1991 Charlie created a mock-Masonic order called the Mystic Sons of Morris Graves, of which Charlie served as Grand Polmarch.

The Northwest School drew inspiration from the natural beauty and distinctive quality of light of the Puget Sound area, as well as Asian aesthetics. They were often called "Northwest mystics" because of the influence of Asian philosophy, particularly Zen Buddhism. Charlie embraced both the aesthetic and mystical aspects of the Northwest School with enthusiasm, although he was more aesthetically drawn to Tibetan Buddhism than to Zen. He also read widely in Hinduism, Alan Watts, and Aleister Crowley.

Charlie went to India in 1970 to study yoga, arriving just after the Beatles departed. He returned in 1972, meeting Ram Dass (Richard Alpert). In 2001, he attended the Maha kumbha mela. Later in the 2000s, he tried to meet Miriam Hirn, Savitri Devi's friend and literary executor, in Tiruvannamalai. All told, he made five trips to the East.

During his time in Fishtown, Charlie built a reputation as a painter. His works were featured in many group and solo gallery shows. In 1980, he moved back to Seattle, where

[3] Charles Krafft, "A State of Mind, Not a Place," December 2001, unpublished, quoted in Mike McGee and Larry Reid, *Charles Krafft's Villa Delirium* (Santa Ana, Cal.: Grand Central Press; San Francisco: Last Gasp, 2002). On Fishtown, see also Claire Swedberg and Rita Hupy, *In the Valley of Mystic Light: An Oral History of the Skagit Valley Arts Scene* (Bellingham, Washington: Good Deed Rain, 2017).

he became a fixture in the local art scene. He became a board member of CoCA, the Center on Contemporary Art.

The second phase of Charlie's career began in 1990, when he started corresponding with custom motorcycle and hot rod pinstriper Von Dutch (Kenneth Howard). Charlie's friendship with Dutch was his introduction to the world of "lowbrow" art or Pop Surrealism. In Charlie's words:

> This is an alternative visual arts scene that has its roots in California custom car culture, surfing culture, and in '60s era underground comix. It's a streetwise aesthetic that has been evolving and spreading out across the globe while remaining almost entirely unnoticed by most mainstream critics, museum curators, and art historians. It exists on the Internet and by word of mouth in its own parallel universe of events, magazines, galleries, shops, and studios in America, Europe, Australia, and Japan.[4]

Charlie's friendship with Dutch also launched his career as a ceramicist. Charlie wanted to paint a portrait of Dutch in a distinctly Dutch medium: Delft-style, blue-on-white ceramic. So in early 1991, he began attending Barbara Henderson's classes at the Northwest China Painters' Guild.

The Von Dutch portrait was completed and shipped, but it was not well-packaged and arrived broken. This inspired Charlie to create "Disasterware," a series of Delft-style plates commemorating disasters like the sinking of the *Andrea Doria*, the explosion of the *Hindenburg*, and the bombing of Dresden. As he told *Salon* in 2002,

> "My idea was to drag plate painting kicking and screaming into the 21st century with these images of

[4] "Artist Series Post #6: Charles Krafft."

things you don't usually find on tableware. It began as natural disasters—like floods—then it went into sociopolitical disasters where," he says, lowering his voice with mock gravity, "I've found the most comfort."[5]

Until this point, Charlie had been a fixture in the local Skagit Valley and Seattle art scenes, but very much a *local* fixture. Disasterware garnered national and then international attention. "The moment I went from easel painting to ceramic painting, was the moment that the world started to take notice of me."[6]

In the late 1980s, Charlie discovered Laibach, the Slovenian industrial music band which makes provocative use of nationalist themes and totalitarian (fascist and communist) aesthetics. In 1994, Charlie helped bring Laibach and other members of its Neue Slowenische Kunst (NSK) collective to Seattle. In late 1995, Charlie went to Slovenia on a grant to make state dinnerware for NSK, which had declared itself an independent state, complete with its own passports. When Charlie arrived, the band declared him the official photographer for their Occupied Europe: NATO Tour. Next stop: Sarajevo, where they arrived in the burned-out city on the day the Dayton Accords went into effect to play a concert (bankrolled by George Soros' Open Society Foundation).

The state dinnerware became a pair of commemorative tour plates, because Charlie's time in Sarajevo inspired his next major project: his famous porcelain guns and other weapons, such as knives, brass knuckles, and hand grenades: "My aim is to produce a delicate arsenal of lifesized ceramic weaponry so gorgeous and patently functionless that they will bedazzle and confound everyone who sees them." He returned to Slovenia in 1997 to make

[5] "Been there, smashed that."
[6] "Been there, smashed that."

molds of various weapons and again in 1999 to display his work in the Porcelain War Museum exhibition. Originally, it was to be held in a gallery, but when the Slovenian military caught wind of it, they offered to host it at their headquarters in Ljubljana.

Charlie continued to come up with bizarre and macabre porcelain projects for the rest of his career. Two of my favorites are "Spone" (human bone china incorporating cremation ash) and his portraits of controversial figures: Adolf Hitler, Charles Manson, Aleister Crowley, Nick Griffin, Kim Jong-Il, Mahmoud Ahmadinejad, Vladimir Putin, Ted Kaczynski, etc., which come in various formats: normal busts, teapots, mugs, and even hot water bottles. His Ayn Rand comes only in piggy-bank form. His Mishima bust portrays the writer's severed head.

I first learned about Charlie when I was living in Berkeley between 2002 and 2005. We first corresponded in 2006. We first met in 2009. He rapidly became one of my favorite people. He was one of the most imaginative, creative, and funny individuals I have ever known. He was utterly unique and irreplaceable.

Charlie was remarkably open to new experiences, people, and ideas. He was willing to listen charitably to any idea from any person. He had a disarming, childlike candor, as well as a devil-may-care spontaneity, which I think were built on enormous underlying resources of courage and self-confidence, as well as a kind of mystical affirmation of the world, not necessarily as good, but as *good enough* for Charlie. I also admired how disciplined and hard-working he was when it came to art.

Sometimes, though, Charlie's frankness verged on brutality. His openness usually served him well, but he often did not seem to understand that other people operate quite differently. His willingness to extend everyone the benefit of the doubt made him an easy mark for cranks, conmen, journalists, and other scum.

Charlie was a voracious and heterodox reader on art, religion, occultism, history, and radical politics. I always kept a notebook handy when I spoke to him, because he was a fount of fascinating recommendations.

Charlie had always been open to radical Right-wing ideas. One of his friends told me that sometime in the 2000s, when he and Charlie were waiting for a bus, Charlie recognized a man he had seen when George Lincoln Rockwell had spoken in Seattle in 1964, when Charlie was in high school. Charlie also had many friends on the Right. I won't name any who are still living. But two notable ones are Von Dutch, who was a self-described Nazi, and Adam Parfrey, the half-Jewish founder of Feral House Publishing, who was *the* central figure of the West Coast Rightist counter-culture. The martial-industrial and neofolk music scenes were also filled with radical Rightists.

But most of these people thought that Charlie was merely a connoisseur of edgy opinions. Charlie was fascinated with intense religious and political commitments, but they were foreign to his personality. He was also quite candid about such heterodox interests. For instance, in 2002 he told *Salon*:

> Why was Ezra Pound a fascist? Here was one of the greatest poets of the 20th century. Why was he involved in this business? Here's a very intelligent guy who knew everybody there was to know and he's completely behind Mussolini. And when they release him from the asylum he's unrepentant.
>
> I'm deeply into exploring the other point of view in a certain time period, the '30s and '40s. I lose patience with the right-wing in America right now. I just think that they're dunderheads. I've become a connoisseur of this kind of propaganda, but it has to be from a certain period—I can't stomach Rush Limbaugh.

You see, I don't have anything to believe in myself, really, and I'm wondering how another person comes into a belief system and becomes utterly convinced—it becomes theirs, it defines their personality, it defines their history as a human being. . . . Drifting into the realm of politics, how does somebody come to believe in a political system and embrace it and work for it and even sacrifice their lives for it, be committed to die for it?[7]

I think Charlie found Rightist ideas attractive for the same reason he was fascinated with the occult and Eastern religions: they stimulated his imagination. But Charlie was not just interested in ideas; he was also interested in people, in *believers*, especially *dissidents*, i.e., believers who went against the current of the society around them. Charlie pursued these interests long enough and stubbornly enough—especially when the guardians of conventional wisdom started pushing back at him—that he eventually became a dissident too.

During his travels in Eastern Europe in the 1990s, Charlie became interested in the Romanian Iron Guard. He actually interviewed Cătălin Codreanu, a brother of Corneliu Codreanu. (This interview is historically significant and needs to be found and made available.) While in Romania, Charlie's contacts mocked the widespread story that Legionaries hung Jews from meat hooks and tortured them during the Bucharest Pogrom of January, 1941.

Charlie's initial reaction was, basically, "Why would people say it if it were not true?" But when faced with diametrically opposed, passionately held opinions, he decided he had to investigate. This led him down the rabbit hole into the world of World War II revisionism. Charlie spent years tracking down every source on the abattoir

[7] "Been there, smashed that."

story. He would read an account, look at the sources, then track them down as well. In the end, he concluded that the Bucharest abattoir was just anti-Iron Guard, anti-Romanian, and ultimately anti-white propaganda. He wrote up his findings and sent them to the Holocaust Historiography Project's Annual David McCalden Most Macabre Halloween Holocaust Tale Challenge competition, which awarded him first prize in 2005.[8]

Charlie also became interested in the related case of Romanian Orthodox Archbishop Valerian Trifa. He was convinced that the case for him being a war criminal was trumped up. In a 2012 interview, reprinted below, he stated, "I'm still interested in trying to help clear his name, and I'm one document away from proving that everything they said about this man was a load of horse puckey."

When I started *Counter-Currents* in 2010, Charlie was an early enthusiast. He did three interviews with Counter-Currents Radio. He attended and spoke at *Counter-Currents* Retreats. Charlie also spoke at the first Northwest Forum in 2016 and attended most of the others. His art adorns the cover of two of our books. He also wrote blurbs for three of them. When Counter-Currents launched the H. P. Lovecraft Prize for Literature, Charlie created the prize bust. When Counter-Currents launched its Centennial Edition of Francis Parker Yockey's Works, Charlie created two plates commemorating Yockey's 100th birthday.

It was at a 2012 Counter-Currents Retreat that we noticed a change in Charlie. He started speaking of "our movement." He had become a white advocate, not just someone who was along for the ride.

Charlie's heterodox interests and political journey were always public knowledge, but it took years for the forces

[8] The Holocaust Historiography Project, Winning Contest Entries, October 31, 2005, https://www.historiography-project.com/contest/2005full_entries.php

of political correctness to catch on. Finally, on February 13, 2013, Jen Graves, an art journalist for the Seattle alternative paper *The Stranger*, published a hit piece with the snappy title, "Charles Krafft Is a White Nationalist Who Believes the Holocaust Is a Deliberately Exaggerated Myth,"⁹ which sent shudders of joy through the human centipede of the mainstream media, garnering coverage in *The New Yorker*, *The Huffington Post*, National Public Radio, and many lesser outlets.¹⁰

Tito Perdue, winner of the first H.P. Lovecraft Prize for Literature, prize bust by Charles Krafft (2015)

⁹ Jen Graves, "Charles Krafft Is a White Nationalist Who Believes the Holocaust Is a Deliberately Exaggerated Myth," *The Stranger*, February 13, 2013.

¹⁰ You can read more about it in my essays "The Persecution of Charles Krafft," *Counter-Currents*, February 14, 2013, and "Freude durch Krafft," *Counter-Currents*, February 27, 2013.

Charlie lost friends and galleries because of the controversy, but it seemed to me that he was most upset with people impugning his sincerity, since being open-minded and honest is what got him in trouble in the first place. He didn't understand that Leftists are joyless cultists who live in constant fear of one another's hysteria and intolerance, so why wouldn't they impose the same conditions on their enemies? Making the entire world their madhouse is what they call "progress." Still, Charlie never expressed any regrets about standing up for the truth as he saw it.

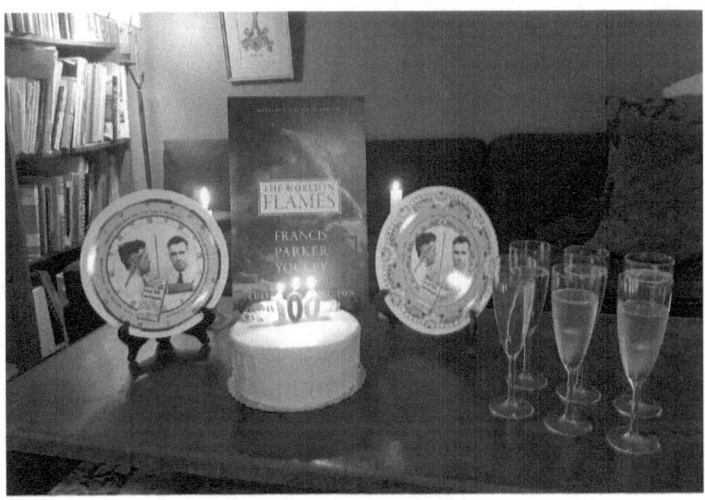

Celebration of Francis Parker Yockey's 100th birthday with commemorative plates by Charles Krafft (September 18, 2017, in Charlie's living room, Beacon Hill, Seattle)

Charlie was famously cheap in his living, travel, and dining arrangements, and he had set aside money for his retirement (his father, Carl Krafft, lived to be 98). So he easily weathered the financial shocks of "cancellation" and found new outlets for his work. He traded fake friends for real ones. All told, he bounced back better than anyone I know who has been "outed" as a thought criminal.

In 2018, Charlie was supposed to take part in a show in Switzerland on weapons in art. But agitation from the usual suspects caused the gallery to pull out. Charlie decided to use his ticket to Europe anyway. He was supposed to depart on Sunday, March 11th. A friend and I had dinner with Charlie to see him off, and he seemed strange. For one thing, he ordered a drink at dinner. Charlie had a drinking problem in his youth but quit. So this was his first alcohol in decades. We chalked it up to pre-flight nerves.

When Charlie got to Europe, however, I began receiving messages from him that could only be deemed "confused." He went to Budapest on March 15. John Morgan and Michael Polignano thought something was off as well. When Charlie got back to the states, one of his friends thought he was having a stroke and rushed him to the hospital on March 23. It turned out he had a brain tumor. He went under the knife that day.

As soon as the tumor came out, Charlie was his old self. I joked that he should tell Jen Graves that he had been cured of "hate." Charlie was fine for about a year, then the tumor came back, and he had another operation. After that, he had difficulty walking, but he retained his creativity and sense of humor. A third recurrence of the tumor was inoperable. He died on June 12, 2020.

After his first surgery, I dedicated my book *Toward a New Nationalism* "To Charles Wing Krafft, in friendship, respect, and gratitude. You really had us scared there for a while, Charlie." By the time the book was in print, though, the cancer had already recurred.

Charlie should have had many more happy and creative years ahead of him, but with his body collapsing under him and his nation collapsing around him, I think he was increasingly ready to face the great mystery, always open to the end. He told a friend a few months before his death, "The seer I want to be shudders agasp, as he stares into a space more vast than death."

THE MYSTIC SONS OF CHARLES KRAFFT

Charles Krafft belongs to history now. In the future, dissertations and books will be written about his life and work. Thus it is important to preserve as much information as possible, especially given the ephemeral nature of online publication. To this purpose, some of Charlie's friends have formed the Mystic Sons of Charles Krafft to gather texts, images, recordings, and reminiscences documenting Charlie's life, work, and ideas.

Our first project is the present volume, which collects transcripts of three interviews that Charlie gave to Counter-Currents Radio, three talks that he gave at Counter-Currents Retreats, his lecture at The London Forum, and his lecture at the inaugural meeting of The Northwest Forum, plus two short written works that he sent to *Counter-Currents* but which I declined to publish at the time.

If you would like to share reminiscences of Charlie, photographs of Charlie and is works, audio versions of interviews Charlie gave to various podcasters, and electronic or print copies of his writings and correspondence, please contact me at editor@counter-currents.com. I will make sure that all such material is archived and made available to scholars.

A NOTE ON THE COVER DESIGN

Although it was tempting to do a Delft-style cover for this volume, we decided not to attempt it because it would inevitably verge upon parody. But still we wanted a cover that was related to Charlie's work. Thus we decided on a white on deep blue color scheme and a design that brings to mind Charlie's nautical-looking Villa Delirium Delft Works logo, which is actually a portrait of Von Dutch.

❖ ❖ ❖

I wish to thank Matt, Hans-Ulrich, Tim, and other Mystic Sons of Charles Krafft for their reminiscences, and one in particular for the cover image; Michael Polignano, Hyacinth Bouquet, and K.C. for their transcriptions; Philippe B. for a scan of "The Handshake"; another friend of Charlie for the Proust questionnaire; James O'Meara and Alex Graham for their help with the index; Buttercup Dew for his proofreading and the video of the London Forum speech; Tito and Judy Perdue for the photograph of Tito and his Lovecraft Prize bust; Cyan Quinn for organizing the Yockey Centennial celebration, which took place in Charlie's living room; and Kevin Slaughter for yet another splendid cover design.

This book is for Charlie.

<p style="text-align:right">Budapest
September 7, 2022</p>

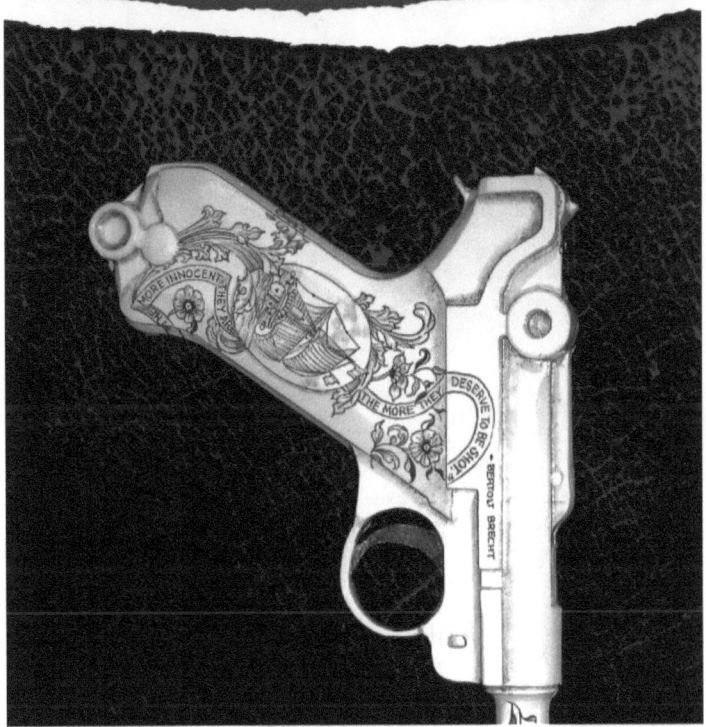

Charles Krafft's art on the cover of Juleigh Howard-Hobson's
"I do not belong to the Baader-Meinhof Group" & Other Poems
(San Francisco: Counter-Currents, 2013)
(Cover design by Kevin Slaughter)

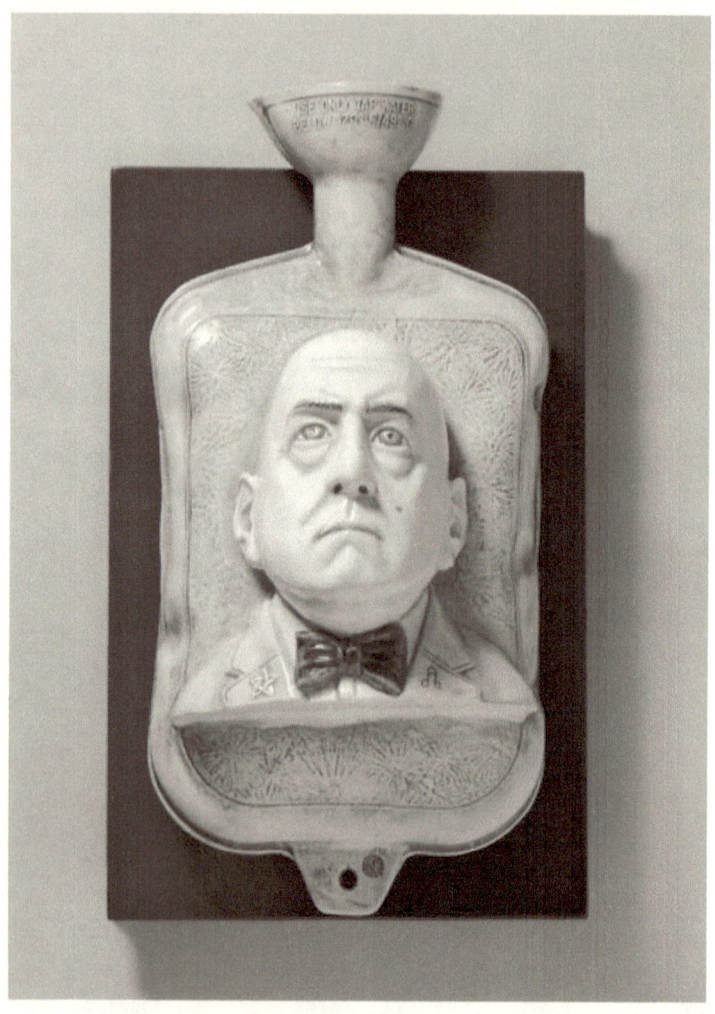

Charles Krafft's *Aleister Crowley Hot Water Bottle*
(Author's collection)

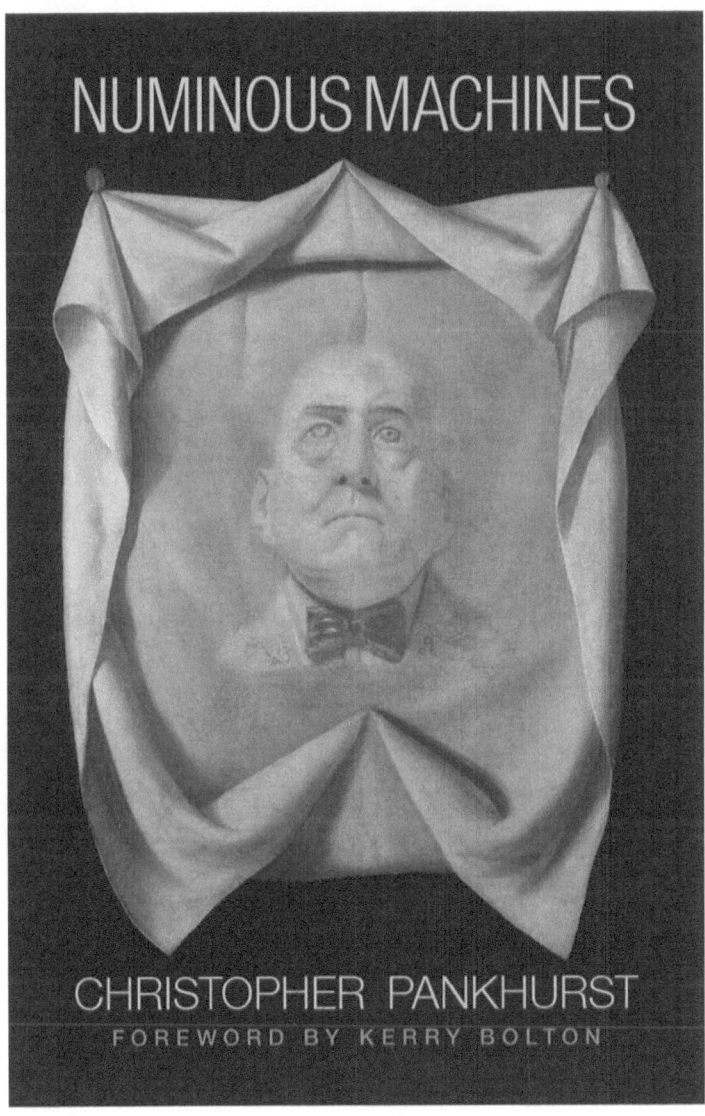

Charles Krafft's art on the cover of Christopher Pankhurst's *Numinous Machines* (San Francisco: Counter-Currents, 2017). The image is a mashup of Krafft's *Aleister Crowley Hot Water Bottle* and Francisco de Zurbarán's *The Veil of St. Veronica*. (Cover design by Kevin Slaughter)

Charles Krafft's Blurbs for Counter-Currents Books

For Kerry Bolton's *Artists of the Right* (and *More Artists of the Right*):

"Kerry Bolton is the Noam Chomsky of the New Right. His double doctorates in theology and encyclopedic knowledge of 20th-century history qualify him as a guru, and as such I recommend his writings on geopolitics, culture, and spirituality to anyone with more than a passing interest in these subjects. Every day since VE Day has been a Marxist holiday for the culture makers of the West. *Artists of the Right* is a declaration of the manifest bankruptcy of this legacy."

—Charles Krafft

For Greg Johnson's *Truth, Justice, & a Nice White Country*:

"Greg Johnson lifted me out of an intellectual gutter of losers and pastors I'd fallen in with after a Slam & The Ice Picks concert in Idaho back before the iPhone. He introduced to me to a loftier level of thinkers who speak and write in complete sentences and don't sport Viking tattoos. Superb writers on the right side of the political spectrum who ended up on the wrong side of history like Ezra Pound, Martin Heidegger, and Savitri Devi. Greg's mentoring moved me off the freeway to prison I was speeding along and put me on the path to full acceptance of my inner tweed and tortoiseshell white self. If he can work a miracle like that for me, he can do the same for you."

—Charles Krafft, Villa Delirium Delft Works

For Greg Johnson's *In Defense of Prejudice*:

> "Imagine an angelic-looking guy in leather pants named Peter Probabilistic who is the lead singer in a supergroup called the Inductive Generalizations. Then imagine you're one of thousands of excited fans who have filled a stadium to see them perform songs from their new chart topper *In Defense of Prejudice*. In what sort of world would a concert like this be happening? If your answer is Disney World® that's wrong. Find out exactly how wrong in this new collection of essays by Greg Johnson."
>
> —Charlie Krafft, Villa Delirium Delft Works

Counter-Currents Radio Interview

April 29, 2012

On April 29, 2012, Michael Polignano and I interviewed Charles Krafft on our Counter-Currents Radio podcast. I want to thank Mike for transcribing our interview.

Michael Polignano: Welcome to Counter-Currents Radio! I'm your host, Michael Polignano. I'm here with Counter-Currents editor Greg Johnson, and our guest today is artist Charles Krafft. Charles Krafft is an internationally known, Seattle-based porcelain artist whose work has been collected by museums and individuals around the world. Charlie, welcome to the show.

Charles Krafft: Thank you very much, hello.

MP: So tell us a little about your background. Where were you born, who are your people, where'd you go to school, that kind of stuff.

CK: I was born here in Seattle, in 1947, to a middle-class family. My father was a Boeing engineer, which actually translates as white-collar executive, and my mother was a housewife. I went to school in the public school system until the ninth grade, when they pulled me out of a multiracial middle school and put me into a private boys' prep school. And because I hadn't started out at that prep school, my study skills were not up to snuff, and I only lasted three years at the prep school. They finally asked me to leave the

year before I graduated. So I ended up graduating from a Seattle public school and not the fancy private school that my parents had put me in. But that school produced Bill Gates and Paul Allen and some other notables, especially around here.

Greg Johnson: Did you go to college?

CK: I ran away from home the day after I got my high school diploma, and went to San Francisco thinking I wanted to be a beatnik poet. There was a West Coast poetry conference going on in Berkeley that I read about, and so I headed for Berkeley, and I hung around the campus there for the two weeks that the conference was going on, and sort of audited classes—which meant I hadn't paid to sit in on them, but I snuck into them or sat outside windows so I could hear the poetry and listen to the dialogue that the poets were having between themselves. At the end of that summer, I was remanded back to Seattle by my family, because I was still underage and they had enrolled me in a community college. When I got home in September, I spent one year in the community college and then, as soon as I turned 18, I headed back to San Francisco to resume my career as a beatnik.

GJ: So is it true that Grace Slick is a cousin of yours?

CK: Yeah. She's my mother's brother's daughter, and she's named after my mother and her grandmother. And in the course of that summer in San Francisco and Berkeley, I got in touch with Grace, because my mother had called Grace to say that I was somewhere in the Bay Area and that if I contacted Grace and their husband, they were to put me back on the plane to Seattle. And Jerry Slick and Grace—whose maiden name was Wing, which is my middle name—told my mother that if I did contact them, they

would not put me on the plane back to Seattle, but they would feed me and house me if I needed it. Well, I didn't need it. So when I went over to Tiburon to talk to them, they were getting ready to launch a band called The Great Society, so there were musical instruments everywhere, and Jerry and his brother Darby were the primary movers behind that band. And we spent the night burning sixteen-millimeter film in a projector and watching the burn marks expand on a screen in their Tiburon apartment. [Laughs]

CK: We also took some gels and put jam in them and squeezed them, so that you had pulsating strawberry jam being projected on the wall. And when I got back to Seattle right after that summer and was in school, I became tangentially involved with a light show company which I ended up being a part up for the next two years. We were doing psychedelic light shows in Seattle, and my light show company got hired by Ed Denson of Takoma Records to go to New York with Country Joe and the Fish for the first Country Joe gig at the Whisky a Go-Go in New York.

I didn't go with them. I stayed in Seattle, and then I went back to San Francisco and worked for another light show company that was started by an underground filmmaker named Scott Bartlett. And I did light shows at a club in the Mission called the Rock Garden, which didn't go over with the hippies because it was run by a bunch of Italians from North Beach, who were just trying to cash in on the fad at the time. They really didn't have a sense of community which the hippies had in San Francisco in 1967, which is when I was there and which was when I left and returned to the Northwest and commenced a career as an artist.

GJ: So, when did you decide to become an artist and what kind of artists and art inspired you, if any?

CK: I wasn't sure I wanted to be an artist; I was more into

writing. And in those days, the poets, the American underground poets, were like rock stars. And so there was Allen Ginsberg and the Beats, and I was inspired by them. Of course, having read Kerouac I headed for the Bay Area because I read *Big Sur*, and [Richard] Brautigan's book, *Confederate General from Big Sur*, had been just released. There was something going on in San Francisco with writing, so I thought if I went there, I would get involved with the writing.

I ended up doing painting, too, while I was there, and showing at the Vorpal Gallery down at Fisherman's Wharf. And so I sort of drifted into painting, because I could make more money, of course, selling a painting than I could a poem, which you don't get paid for unless you're an academic, I guess, unless you're teaching it. It's really a rough row to hoe to be a poet without a job, if you understand. And I just realized almost immediately that if I was going to eat, I could probably eat better trying to sell art than trying to get my poetry published.

GJ: Right. Tell us about Von Dutch, I understand you were friends with him.

CK: Von Dutch—his real name is Kenneth Howard—he was a hot rod pinstriper in Southern California who was really famous when I was a kid, because he had designed those baroque pinstripes that hot-rodders were putting on their cars. His father had been a sign painter, and his father had told him he could probably make a living as a sign painter, too. And when Dutch got out of high school, he went right into car pinstriping, and he was also a mechanical-minded guy, and he built motorcycles, he built cars, he made knives—really excellent knives—and guns from scratch. He was a powder man on Steve McQueen movies, and an all-around master of the manual arts.

So one day on my family's first television set, I recall

coming home from elementary school, I think it was, and flipping it on. And there was Von Dutch pinstriping character actor Keenan Wynn's motorcycle in his shop in Calabasas, California. And Von Dutch struck me as a really good-looking guy with a flat-top haircut and a white shirt and dungarees, and his house was filled with art and lamps that he'd made from musical instruments. And we got a little TV tour of his pad, and then they showed him in action. And I had been reading custom car magazines to get ideas for models that I was making.

So I knew about Von Dutch when I was about 13 years old, and I reconnected with him later at about the age of 40, because I had remembered what an inspiration he had been to me back when I was almost a preteen. And so I contacted him; I ran him down—he was living up in Santa Paula, California—and I started correspondence with him. And he was on his way out, due to alcoholism. I did get a chance to meet him, finally, after two years of correspondence, two months before he died in 1992 at the age of about 63. And he was pretty much burned out behind his hard living and his alcoholism, that he needed to do what he did. I mean, he was a maintenance alcoholic, so he couldn't really do what he did without a beer in his hand. And essentially that's what killed him. His liver just crapped out on him.

He's a namesake of an international, successful line of leisurewear, but he died before that was launched. So when you see people with Von Dutch clothing on, that is a completely different operation than Dutch himself, who was a bit of a loner and a difficult individual to get along with, I've heard. And a genius, and an inspiration to a lot of artists in the lowbrow genre, which is an art movement that sprung out of populist imagery, that includes movie posters and pulp magazines and paperback book covers, custom car lacquer finishes in flame, and pinstriping jobs, and monster art that was popular when we were kids (and we put these

decals on our bikes), and comic books, tattooing, circus banners, and just a host of prosaic things that people weren't paying too much attention to, until this lowbrow movement was launched from the Laguna Art Museum. And I can't remember what year it was, but they did a Von Dutch, Big Daddy Ed Roth, Robert Williams show that just became super successful, and it's still going on. I mean, it's inspired a whole generation of artists that have their own galleries in magazines and kind of a rockabilly subculture that goes along with that.

GJ: So do you consider yourself inspired more by lowbrow art than high art?

CK: I consider myself as straddling the two, because when I started out as a salon painter I was inspired by the Northwest School, that included Mark Tobey and Morris Graves, Kenneth Callahan and Guy Anderson. And these guys were serious fine artists. So I modeled my existence in my art, my lifestyle, after them, and then later, after getting in touch with Von Dutch, I switched caps, switched berets. I was trying to be rather serious and metaphysical, and then I went kind of ironic lowbrow.

MP: So what defines the Northwest School?

CK: An interest in Asian art and Asian spirituality: Zen Buddhism, the Baha'i faith, the Book of Revelation, I guess. They've been called the Northwest mystics.

They were launched as a school in 1953, by *Life Magazine*. A photographer and a writer came out to Seattle and photographed these guys in their studios, and they became internationally famous for a while. Mark Tobey remained really the most famous of them. He was the first American, I believe, to ever have a show at the Louvre. I think, but don't quote me on that. And Morris Graves was right after

him, as far as the fame goes. And these guys didn't leave the Northwest. Anderson and Callahan stayed here. Their reputations are monumental in the Pacific Northwest, but no one outside the Northwest really knows about them. But history books usually do include—twentieth-century art history books—Mark Tobey for sure, and maybe Morris Graves. So those guys inspired me.

GJ: So the art that you're famous for now is your work in porcelain. When did you get into doing that and how?

CK: Well, during the two years when I was trading letters with Von Dutch, I wanted to do a tile portrait of Von Dutch in the "Dutch Delft" style, and I didn't know how to paint on a ceramic surface. So I enrolled in a hobby crafts class for china painters. And I attended this class for a winter, with these little old ladies who took a big shining to me because I was a "real artist," and they consider themselves just hobbyists. But they were really adept at what they did, and they taught me a lot about china painting and the history of ceramics. So it happened when I switched from painting on canvas to painting on ceramics. That's when this happened. And the ceramics took off, and the paintings I don't think they ever would've—they were too provincial, I think, to ever have received as much attention as these ceramics had received, and continue to receive.

GJ: You do great things, I think. Some of your projects are really quite fascinating and really funny and witty. Your porcelain skateboards, your porcelain weapons, your Delft Disasterware, your Spone series, things like that. Could you tell us a few things about your different projects and various exhibitions you've had?

CK: The best exhibition that I think I ever had was a show

of porcelain weaponry, at the Defense Ministry headquarters of the Republic of Slovenia in Ljubljana. And I collaborated with the Slovenian Army to have a show of these things at the epicenter of their intelligence apparatus. And that was the biggest feather in my beret, to be able to collaborate with an Eastern European army on an art show. So there's the Porcelain War Museum project, which was inspired by a visit to Sarajevo that I made with the industrial band Laibach in 1995.

Other projects have included the Spone relic-wares, which are human bone china containers for crematory ash. And I thought this might revolutionize the funerary arts but it hasn't really taken off. I did get myself into *Ripley's Believe It or Not!* with this human bone china.

I've done some things up with a fellow named Larry Reid, producing art events that included a Dale Chihuly glass-smashing auction, and a séance to get in touch with Morris Graves on the anniversary of his birthday—it's his centenary, his hundred-year birthday—to ask him what direction art was going to be going in. And other kinds of public events that were supposed to be fun, rather than too heavy and too abstract to really get your mind around, unless you've got a Ph.D. in postmodernism. We wanted to make art entertaining. Larry Reid and I, we started this thing called the Mystic Sons of Morris Graves, Seattle Lodge 93, which is a mock Masonic Lodge. And periodically over the last decade we've done these events that we invite the public to, and they usually enjoy what we put on.

GJ: So I understand that you've had a fairly long association with Laibach. How did that happen?

CK: I was a volunteer program committee chairman for a nonprofit arts space in Seattle called CoCA, which is Center on Contemporary Art. And during my tenure as the chairman of the programming committee, I thought because I

was noticing the political correctness of the arts funding happening with the federal government NEA grants we were applying for, I wanted to go against the grain and put on a show at CoCA that looked fascistic. And I stumbled on a Laibach album cover in a record store that looked very fascistic, and I was kind of perplexed by it. When I turned it over and read what I was holding, it turned out this record was made by a collective in Slovenia called the Neue Slowenische Kunst. And I thought if they're an art collective, maybe they've got some art they would send to Seattle so that we could make an exhibition at CoCA of it.

And I did this, and we brought the NSK artists' Moscow Embassy Project exhibition to Seattle and then flew the band over to do a concert at the Moore Theatre in Seattle. Fights broke out after the concert in Seattle, because the Seattleites were too stupid to understand what they were seeing was an ironic take on totalitarianism, not a skinhead performance.

The Laibach guys were dressed as German submariners, they were wearing black turtleneck sweaters. And, of course, the music was very martial sounding, and the visuals were martial looking. A couple of my friends outside— for some reason this big scrap broke out. I heard later that for some reason they thought Laibach was a fascist band. And I have to say it, that's not what they are. They're making a mockery of totalitarianism, by trying to out-totalitarianize the State. They're holding a mirror up to the State, trying to be more of a State than the State is.

MP: So you had some conversations with them, did you actually get a sense of their views on things? Their political views?

CK: While I was at CoCA, a residency program flyer came into the office which was offering a collaboration between American artists and Eastern European artists. It was going

to be funded by the Citizens' Exchange Council, which puts Eastern European and Russian artists together with Americans. And vice-versa: they send us over there, and they bring them over here. So I applied for a grant to go to Ljubljana and work on some ceramics for the NSK collective, and that's where I got immersed in their "retro avant-gardism," which is a philosophy about what they do that they've spent a long time honing.

It's very postmodern; it's extremely academic. It really is based on trying to go back in time, "retro," to the avant-gardes, the avant-gardes before World War II; examine what the avant-garde artists were doing with the new technologies available to them—which were, they say, co-opted by Capital and Power, and used as propaganda tools in World War II. So if they go back in time to examine these technologies and what happened to them, examine the trauma they created, maybe there's a way to get modernism back on the track. That is their idea. Can modernism be put back on the track to, I would assume, some sort of utopian destination or resolution that resembles Russian Constructivism? They're very inspired by Malevich.

GJ: So they're not nationalists of some sort, then?

CK: Yes, they are. They're nationalists. This is interesting, because they consider themselves Slovene nationalists. But they say [their] nationalism has been impacted by [their] location at the crossroads of the East and the West. Slovenes speak English, Slovenian; they spoke Serbo-Croatian, Italian, and German. They just grew up with this because of where they are. And so their nationalism looks Catholic, because they're Catholics. And it also looks a little bit Third Reich-ish (although they've distanced themselves from that, now), and a little bit Soviet Russian, and a little bit Western pop. Pop art, if you can imagine. A Mickey Mouse reconfigured as some sort of a military badge, worn by a

stormtrooper.

MP: So I understand that the Neue Slowenische Kunst issued their own passports for a period.

CK: Yeah, they upped the ante on their collectivism. They're a collective, that includes the band Laibach; a painters' group, called IRWIN; a theater called Noordung, Cosmo-kinetic Cabinet Noordung; a design business, called New Collectivism; and the philosophy department, the Department of Pure and Applied Philosophy. So, these guys work together, and they decided to up the ante on this collectivism and declare themselves a trans-global borderless State-in-Time. They found a passport company that makes passports for European countries to make one for their State. And anybody can become a citizen of the NSK State-in-Time.

But the NSK collective itself always remains, because they say they're totalitarian. The same fourteen people that started the group in 1990 or something like that, '92 or '89.[1] Laibach was banned in Slovenia, and this collective erupted as a result of them being banned to play their music.

Does this make sense to you? It's kind of complex.

GJ: Yeah, yeah . . .

CK: There's lots of books about it that can be purchased, including one called *Interrogation Machine: Laibach and NSK* by this Ph.D. in London whose name escapes me now.[2] But it's all laid out, there's a movie called *Predictions of Fire* by Michael Benson that you can request and watch, and that

[1] NSK was actually founded in 1984; Laibach was formed before the rest of NSK, in 1980.

[2] Alexei Monroe, *Interrogation Machine: Laibach and NSK* (Cambridge, Mass.: The MIT Press, 2005).

gives you the real rundown on what they're doing, and why.

So I was inspired by them. I wasn't political until I went to Slovenia and got involved with these guys, and I came back sort of politicized, as far as the imagery and my art went. And of course I'd seen what Sarajevo looked like in 1995, which was the tail end of the war in Yugoslavia. I was absolutely appalled at this siege that went on for four years, and the infrastructure of the city was completely destroyed. And that inspired my idea of making porcelain guns, because I saw so many Bosnian militiamen with AK-47s strapped to their backs marching around the city.

GJ: You said you became political during your time working with Laibach. I understand that your thinking has evolved in the direction of the European New Right, for lack of a better term. Can you tell us a bit about how that all happened?

CK: Well, it turns out that Laibach, they're nationalists, Slovene nationalists, but they're also Marxists. Do you know who Slavoj Žižek is, the Slovenian philosopher?

GJ: Yeah.

CK: He's a Marxist. And so these guys have a nostalgia, let's say, for Yugoslavia as it was when Tito ran it. They call that "self-managing socialism." So they have this nostalgia for their socialism that they grew up with. They present this New Right, hardcore image, but we can call them on the Left, and we can call them communists. So after looking into Žižek and realizing that what these guys were actually doing was communistic and collectivist, I decided that I would not become a slave of their State, and take my art in a different direction. If you want to call it New Right, that's fine.

I went off to Romania to do some research on the Iron

Guard, as a result of a crush I had on a Slovenian woman named Michaela. In Slovenia, Michaela is the feminine of Michael, and they name their children Michael and Michaela, after St. Michael. And I remembered that there was a paramilitary organization in Romania called the Legion of the Archangel Michael. As a result of meeting Michaela and sort of falling in love with this Michaela person, I got involved with Romania and the history of the Legion of the Archangel Michael.

I took myself to Romania on two different occasions, and I really enjoyed the people that I met in Romania that were still sort of nationalist, Romanian nationalists. It's all completely—it's proscribed, let's say, it's demonized. Post-World War II, nationalism in Eastern Europe is totally demonized. But these guys are sort of carrying the torch of Corneliu Codreanu and his idea of autochthony about preserving a culture that has its traditions.

Autochthony, that's what I came away from Romania admiring. It's nationalistic and not globalistic, and I'd guess you'd put me on the Right instead of the Left now. But I consider myself hopefully beyond the paradigm. I don't know really where I'm headed with what I'm doing, except I don't like globalism. I don't like the homogenization of culture. I don't like postmodern art. I don't think there's too much to a lot of it.

GJ: I understand that you actually met members of Corneliu Codreanu's family. Can you talk a bit about that?

CK: Well, I went to Bucharest. I got in touch with this group called New Right, "Neue Drepta." There was a guy there that I looked up named Tudor Ionesco. He introduced me to Corneliu Zelea Codreanu's youngest brother, Cătălin Codreanu, who was 90 years old when I met him, and married to a painter. They lived in this very humble block apartment, one of those very depressing commie

block apartments that Ceaușescu put up when he destroyed a third of Bucharest. Cătălin Codreanu had never met an American before, so he wanted to talk about Ronald Reagan. And I'll tell you what, I'm no Reaganite. I didn't like Reagan, and I didn't really want to talk to him about Reagan . . . That's who he thought was the great guy in the West at the time. Cowboy Ronald Reagan, with a cowboy hat. When I needed a translator, Tudor was my translator. I made a great movie about this interlude, this meeting with history, actually. And I haven't done much with that yet. It's still sitting unedited, in a pile of film that I've got here. But someday I'd like to upload it to the internet.

GJ: Yeah, that would be great to get out there.

CK: I need a translator to come in and help put some dialogue underneath it.

GJ: Subtitles.

CK: Subtitles, yeah. Either that or a voiceover. Because he died two years after I met him. They put them in jail in 1945. He was never a member of the Legion of the Archangel Michael, but he was a political liability, and he ended up in one of those communist prisons with the other Iron Guardists who languished in these dungeons until an amnesty was declared, in about 1965.

There was a *Putsch*, and the Romanian Army put the Iron Guard down in 1941. And I went to Romania to find out more about the three days of anarchy during the time that the Romanian Army grabbed power. They were sharing power for a while, and then Marshal Antonescu relieved these Legionaries of their civic posts: at the post office and the police departments—all over the country—he said, "It's over; you guys got to go." And these Legionnaires fought back. They wouldn't put their weapons down, and fighting

broke out in Bucharest.

I was really interested in learning more about that, because I became interested in the case of Archbishop Valerian Trifa, who was the first Nazi war criminal flushed out of the United States. Well, he wasn't a Nazi for beginners, and the case against him was trumped up. I'm still interested in trying to help clear his name, and I'm one document away from proving that everything they said about this man was a load of horse puckey.

GJ: Well, that's really interesting. Can you tell us a bit—just to shift gears a bit—can you tell us about your favorite artists, specifically painters and schools of painting?

CK: My two most favorite artists—I'm going to stick with these guys until I die—are Morris Graves and Von Dutch. I wanted to be Morris Graves when I was a young man, and I went off to live in a rural introspective setting and stayed there for a decade, and immersed myself in Tibetan Buddhism and reemerged as an urban lowbrow artist. So those two guys are the biggest inspirations in my life.

The kind of art I like? I like all kinds of art.

My current favorite artists are Belgian Conceptualists: Jan Fabre, Panamerenko, and Wim Delvoye. I think there's a lot of interesting and important art coming out of Belgium right now.

GJ: What about music? What sort of music do you like?

CK: I like worldbeat music mostly, and some of this neofolk music like Blood Axis, Michael Moynihan's group. I listen to Laibach, of course. I listen to Rammstein. I just went crazy—I'm late to Black Sabbath. You know everybody was already through their Black Sabbath period when I got excited about Ozzy Osbourne. I could not stop listening to Ozzy for some stupid reason—and in my 50s. And

Rammstein I had heard about, all the guys in Laibach were complaining about Rammstein stealing their *shtick*, you know, which included the logo the Malevich equidistant black cross. It became Rammstein's logo. That was Laibach's logo. And then singing in German—growling in German—was a Laibach trope which Rammstein turned into an arena rock sensation.

So I went through this Rammstein period. I couldn't get enough of Rammstein, and I'm still sort of in it. With this last album I'm not so keen on them anymore, but I'm going to go to their concert when they come on May 18th. I'm looking forward to that. I saw the last one that was done here, and I'll go to the next one.

So neofolk and worldbeat music. Those are my favorites.

GJ: Well, what you do is both painting and sculpture. Tell me who are your favorite sculptors.

CK: Hmm, let's see. Sculpture, that's a hard one to pinpoint. I would say Wim Delvoye, the Belgian, he makes sculptures. There's some sculptors around the Pacific Northwest that are friends of mine. One of them is Ed Nordin, who does nature, birds primarily, in bronze. Michael Leavitt and I are collaborating now on something called the Pitchfork Pals teapots, and he's a good sculptor; he's a young guy who's really facile, and he can do anything in his sleep in the way of capturing a human form, or a face, or an object. He's just really gifted in that way.

So Michael Leavitt, my collaborator. Ed Nordin is a great guy I grew up with. And as far as the avant-garde, blue-chip stuff, Wim Delvoye from Brussels.

MP: You've traveled pretty widely in India. What drew you there? And what religious beliefs and spiritual practices do you follow, if any?

CK: I was a hippie after—what do you call someone who comes after?—I missed the beatniks.

GJ: You were a late beatnik.

CK: Yeah, I was what you might call a post-beatnik, and then a hippie. I got interested in Tibetan Buddhism as a result of being a hippie. Because we had a really great department at the University of Washington, the Far Eastern Department. We brought the first Tibetan refugees out of Tibet and planted them in the middle of Seattle, so I grew up with Tibetan lamas wandering around the University District doing their mantras in those gorgeous robes of theirs, maroon and gold. So I had seen Tibetans, and I knew a little bit about Tibet. I had read everything that this fake guru named Tuesday Lobsang Rampa wrote about Tibet. He wrote a novel called *The Third Eye*, that was strangely popular in the '60s with kids, along with Carlos Castañeda and those Yaqui Indian tales—everything bogus, of course—but had a spiritual message.

I ended up going to India and running into Baba Ram Dass, first in New Delhi and then in Nanital, which is a hill station up north. And then I met Neem Karoli Baba, who was a big inspiration for Baba Ram Dass and Krishna Das, the *bhajans*—do you know about *bhajans*? They're Indian devotional songs? They're repetition, call and response songs, yoga music.

GJ: Okay.

CK: This guy named Neem Karoli Baba inspired a lot of Western musicians to take up East Indian sitting and music playing. Jai Uttal, Krishna Das, are two disciples of Neem Karoli Baba.

Oh, Bhagavan Das, he's the handsome surfer that led Richard Alpert to Neem Karoli Baba. And all that had just

become kind of legendary. So I went off to Rishikesh and studied yoga at the Yoga Vedanta Forest Academy, which was an ashram started by Swami Shivananda. And I enrolled in a course for Westerners there that lasted for two months, and they taught me Hatha Yoga and Raja Yoga, and I practiced that kind of assiduously for let's say two years, and then it fell by the wayside, and I'm not a yogi.

I don't have any spiritual practices anymore, to tell you the truth. I'm still curious about Asian spirituality, and I love to hear stories about saints and yogis and lamas, you know? It's a romantic kind of thing that I enjoy.

I'm just a huge, fat pig! [Laughs]

MP: [Laughs]

CK: I eat meat, and I don't pray, and I don't sing . . . It's just terrible! [Laughs] I should do something with myself, but I'm a couch potato!

MP: So, were you a believer for a while?

CK: Oh, God, yeah. I was on the path! I wanted to be a Bodhisattva! Get enlightened, and then enlighten everybody else.

GJ: Did you find that you had an aesthetic attraction to Tibetan Buddhism, as opposed to, say, Zen? Does it vibrate more with your aesthetic sensibilities, or . . .?

CK: Yeah, because it had more demons in it. [Laughs]

GJ: [Laughs]

CK: There's more skeletons dancing around, and there's a lot of sorcery and tantra involved. Zen was sort of a little bit too clean for me, I guess. Although I really like Alan Watts,

of course. I listened to him on KPFA Radio, and I was a radio engineer in Seattle, and we used to do Alan Watts up here, and, God, I loved Alan Watts. And then I love the idea of him being down in a houseboat on Sausalito with him having a salon, just everybody coming and going and being the host of this party that just went on and on and on.

GJ: I love Alan Watts, and I love Rammstein. I've written about both of them at *Counter-Currents*. The aim of *Counter-Currents* is to provide a forum and create a network that fosters a North American New Right. We're trying to promote ethnic consciousness and pride among European-Americans, and the ultimate goal is that we'd like to see a white homeland emerge in North America, and we think that artists are a really important part of that metapolitical project, and in the last century, in the first half of the last century especially, we have some of the greatest artists who were in tune with broadly New Right ideas. You had people like Salvador Dalí and Arno Breker, and in literature you had Nobel Laureates like Yeats and Knut Hamsun, Ezra Pound, D'Annunzio, D. H. Lawrence, and all these other people.

Now, the closest thing to that today is the neofolk music scene. We want to do our part to encourage more of a new nationalistic artistic and literary scene. So, Charlie, as an artist, do you have some ideas about how we might be able to promote that?

CK: You know, I don't know, other than using the graphics that are being developed for this neofolk scene as decorations on your website and bring people's attention to the visual side of that music production, because they're doing some nice things with graphics there.

I can't remember this Swedish artist who moved to Iceland because he was a nationalist. Do you know who I'm talking about? He does these post-apocalyptic oil paintings

that are really haunting.

GJ: Are you thinking of Odd Nerdrum?

CK: Yeah, I am. I'm thinking of Odd Nerdrum.

GJ: I think he's one of the greatest painters since Rembrandt, myself. I've never gotten in touch with him, though.

CK: You might want to write about him at your website.

GJ: Yeah. We want to encourage as much art criticism and discussion as possible, and we're publishing Kerry Bolton's essays on various artists of the Right.[3] We hope that if we hold these people up as exemplars, we can create a tradition where people might want to imitate them.

CK: What about this, you know, René Guénon—it's called Traditionalism, or Radical Traditionalism. You know about that?

GJ: Oh yeah, we're very big on that.

CK: Aren't there artists that fit into that kind of category?

GJ: I can't really think of anybody except for Julius Evola, who was a Dadaist.

CK: Right, he was. He was a painter—you know, I've seen his paintings; they're not that great.

[3] Collected in Kerry Bolton, *Artists of the Right: Resisting Decadence*, ed. Greg Johnson (San Francisco: Counter-Currents, 2012). Charlie wrote a blurb for this book, which we re-used for its sequel *More Artists of the Right*, ed. Greg Johnson (San Francisco: Counter-Currents, 2017). See page xx above.

GJ: Yeah.

CK: God bless him. I mean, he was there.

GJ: Well, he was a much better writer than he was a painter. And he found his forte with his books.
 You know, people sometimes describe Laibach's work—and they describe your own work—as "postmodern," which I guess is their way of saying they really hope you're being ironic rather than serious. What's your view of postmodernism?

CK: Well, I think a lot of this postmodernism is kind of an academic exercise in futility, to tell the truth. I feel the same way about "language poetry" and critical theory. I don't understand it; it doesn't make any sense to me. So when I start to see postmodern language being bandied about in these academic magazines I would thumb through at the newsstand, I didn't know what they were talking about. And the more I look into it, the less I'm inspired by it. I think it's fraudulent, to tell you the truth! [Laughs]
 It doesn't have to be that complex and negative and mysterious. I mean, come on! Why do we need all this? Why can't we just get the message from looking at something? Why do we have to get a Ph.D. to understand it? This seems ridiculous to me.

GJ: I got a Ph.D. in philosophy and—

CK: Well, that's philosophy; we're talking about art. I don't want to have to have a Ph.D. to go into an art gallery or museum and appreciate what I'm seeing.

GJ: Right. But I was going to say: I am a Ph.D. in philosophy, but I write criticism. I write movie criticism, I write art criticism, things like that. You don't have to have a Ph.D. to

understand art, and you certainly don't have to have a Ph.D. to understand the things that I write about art, and I just don't get the necessity of using this hermetic, ugly jargon that comes out of postmodernism. It doesn't add anything to my understanding of what's beautiful or funny or interesting in the world.

CK: Well, it also undermines the notion of meaning in everything. Nobody has any kind of trust anymore in what is being said or being created, because according to the postmodern critical theorists, it amounts to nothing. It's a big zero, right?

GJ: Right.

CK: The language itself, it doesn't mean what it says. And so if you can't trust the language, how can you trust the visual arts and music that comes out of it? That's what I think. I mean I'm going, "Postmodern, wait a minute, I don't trust this."

So, "postmodern"—is that the end of history? I'm not quite sure I even know what postmodern means.

MP: It seems like a rejection of all the old principles. Like the Golden Mean and symmetry, and things that people have traditionally found pleasing, they try and go counter to.

CK: Well, don't you think this comes out of French existentialism? What do you think? I track it back to existentialism. Post-war, you know, France and Sartre and everybody. And these postmodern philosophers, the French ones.

They sort of just wrecked everything, as far as I'm concerned. They just came in, and they just wrecked it. They just tore it all down. So what am I? I'm some sort of a . . . A nostalgia for beauty, I guess. And craftsmanship. I really

like good craftsmanship.

GJ: We went to this big Picasso exhibit here in San Francisco last year, and I went from room to room. I don't dislike modern art as such. They had Cubist paintings by Picasso and Cubist things by Braque on the same wall. Practically the same color schemes. And I looked at the Braque, and I looked at the Picasso, and I said, "Picasso is just a sloppy artist. He's sloppy about drawing. He's sloppy about the basic underlying craft elements that have to go into good art." And I just got so tired of the ugliness of what he would paint, but beyond that it just offended me that his technique seemed so very sloppy, very unadroit. And so I went away thinking, "I don't dislike modernism, but I would like it well-done." And you can really see whether it's being done well or badly.

CK: Well, there are those genres in mdernism. And I've discovered that the people that are the big names in those genres are usually my least favorite artists that paint that way. So it's interesting about Eastern European artists, because not many Eastern European modernists ever got their names exposed to Westerners, you know. So my friends in the IRWIN group got a grant from the German government to go and unearth the history of modernism in Eastern Europe, and it includes numbers of artists that we've never heard of that are better than the ones that we see who have those giant coffee table books for sale in all the museum stores and bookstores.

I've never even heard of some of these people, and they're just patently better painters and better sculptors than the people that I'm used to seeing who are being celebrated as the pinnacle of modernism.

I can't rattle off a lot of names because these people are unspellable and unpronounceable to me. I don't speak any language except English, but, Christ, they're really adroit

and overlooked just because of their location. They got infected by modernism and they went to paint modernistically, and they did a better job than everybody in Paris at the time.

I found the same thing in Belgium. I went to the Belgian Impressionist museum. I had never heard of any of these Belgian Impressionists and Post-Impressionists. And I spent three hours in that place just marveling at their skill. It was wonderful. I just had a great art experience in Belgium. And everybody goes to Paris to have one! They should be going to Belgium! [Laughs]

GJ: [Laughs] One of the fascinating things about artists like Filippo Marinetti and Ezra Pound and Wyndham Lewis and others in the first half of the twentieth century is the energy and the seriousness that they put into forming movements and promulgating manifestos. If you were going to found an artistic school or a movement, or just give a name to the kind of work that you do, what would you call it? What would the principles be? What are the goals?

CK: Well, I haven't worked out the principles, and I haven't worked out the goals, but I really like the name National Futurist, which isn't mine; it belongs to Constantin von Hoffmeister. And I just think that would be an umbrella term that I could probably live with. And it's totally unoriginal, but I just like the ring of it. And I haven't come up with anything better. I've been racking my brain for a couple of years trying to think of a name of a good movement, and I haven't been able to do anything better than National Futurism, and I don't agree with Hoffmeister on some of his principles, but for some reason I just like the ring of that name.

GJ: Well, what we'll do is you and I can join his movement . . .

CK: Yeah?

GJ: And we'll vote him out, two to one.

CK: Well, can you vote? I mean, really. We'll just have to kill him, I think. [Laughs]

GJ: [Laughing] Okay, okay.

GJ: Do you have a website?

CK: No, not really.
 I've got this really lame, dated—it's lame because it's dated, it's not state of the art—CharlesKrafft.com. You can go there, but you're not going to be very impressed with it. I haven't kept it up. I kept the name, CharlesKrafft.com, but the website I need some help with from somebody that knows a lot more about computers than I do.
 Can I say something about my artwork? If people that are listening to this want to see it, just put my name into Google and punch "image search," and then a couple of pages of all these images of what I've done will appear, and then you can follow those leads to the places that have published that picture. And it will lead you to galleries and blogs and other kinds of things. But for an overview of what I do, the best thing is just to run my name through a Google image search.

GJ: That's a great idea. Who needs a website?

MP: You might try looking in—there's a blog, a photo blog called Tumblr.

CK: Yeah, you know I'm on Flickr, I've got some stuff archived on Flickr, but I couldn't give you the website URL

because it's a string of numbers and letters I haven't memorized.

GJ: Well, it'll come up with the Google image search, too.

I've been re-reading Frederic Spotts' book; it's called *Hitler and the Power of Aesthetics*. And it's one of my favorite books about Hitler and the Third Reich because it's one of the most fair-minded books I've ever read. And one of the things it underlines to me is the difference between art policy in Germany and art policy in Fascist Italy. Because one of the things that the Italians embraced was modernism. The Futurists were a modernist art movement; there was a movement called Novecento that was a modernist art movement.

And it's interesting, because Hitler didn't have any liking for anything modern, and yet a lot of his own inner circle had really strongly modernist tastes. People like Goebbels really liked Edvard Munch, and Van Gogh, and they thought that the last thing that they needed for National Socialism and the thing that was furthest from the spirit of their age were nineteenth-century minor German painters that Hitler liked, like Spitzweg. So there was this fascist, steely Romantic modernism that was sort of aborted in Germany, but still it was very powerful in Italy.

Do you like Italian Futurism? Do you like Italian Art Deco? What do you think of all that?

CK: Well, I like the Vorticists. Wyndham Lewis, he's a guy that I sort of overlooked earlier on, but I'm revisiting him and realizing that he's better than I thought he was. Balla, I don't know much about Marinetti, what he painted, but I like those Italian Futurist Vortex paintings where everything is triangulated and put into these crazy perspectives. Including that beautiful 360-degree Futurist sculpture of Mussolini's head. Do you remember that thing? It's a face

but it doesn't look anything like a face because it's spinning?[4]

GJ: Right, right, exactly. I know that one.

CK: That I do like. I don't know too much about what was going on in Germany at the time. I can't rattle off the names of their painters. But I liked their design: the industrial design, the military design. But I can't say who was great in Germany, although [Franz] von Stuck—would you consider him? Where would you put him, because I like him.

GJ: Well, von Stuck died in the 1920s. He was a Munich painter. He would fit in more with Symbolism as a movement, in my opinion. I think he's one of the great nineteenth, early twentieth-century painters, myself.

CK: What about those two painters that the Frye Museum in Seattle featured that were metaphysical?

GJ: Gabriel von Max and Albert von Keller?

CK: Yeah, don't you love those paintings?

GJ: Those are fantastic. They were nineteenth-century, south German, Munich academic painters.

CK: Well, they were weird.

GJ: They were fantastic. They were on the highest level, I thought.

CK: Gabriel von Max? What's his name?

[4] Renato Bertelli, *Profilo Continuo* (*Testa di Mussolini*) (*Continuous Profile* [*Head of Mussolini*]), 1933.

GJ: Gabriel von Max. Yeah.

CK: Those monkey paintings. Aren't those the most splendid things you've ever seen?

GJ: Oh, yeah.

CK: Some of the most splendid stuff you've ever looked at? I mean, those monkey paintings just slay me.

GJ: Yeah, yeah. I think they were tremendous painters. And of course, modernism has pretty much consigned all of these people to the footnotes, now. Especially in English-speaking countries. And it's an amazing resource, the Frye Museum, because they actually have it as their mission to provide a place where people can see this kind of work. So it's a great place.

CK: I like—who's the playwright from Sweden that was also a painter, and a photographer and a musician? I can't remember his name right now. He had that little thing on *YouTube* . . .

GJ: Is it Strindberg?

CK: Strindberg, yeah. That Strindberg, that guy was a great painter.

GJ: You know, I've never seen his paintings.

CK: Oh, you must. I'll show them to you the next time I see you. They're just great, they're landscapes, and they're full of Scandinavian storm clouds, [laughs] among other things.

GJ: Well, I'll have to see that.

CK: I like Strindberg.

MP: The people who order your artwork, where are they located? Across the world, or locally, or . . .?

CK: I'm preparing low-resolution photographs of my work for a book company in Berlin, Gestalten Verlag, they're interested in putting out a book about it. And I'm going to be in another exhibition in Paris, sort of this lowbrow group in Paris want to do a show that's going to include me, and they're going to publish a catalog, so.

I have a Japanese collector; there's a guy in Japan that likes my early paintings. He doesn't like the blue and white, Delft Disasterware as much as he likes what I was doing when I was out living in the country painting landscapes Zen-style.

So, they're everywhere. They're in Seattle. They find me on the internet. I have a gallery in Australia, Seattle, San Francisco—I don't have one in New York, that's interesting—Los Angeles, Amsterdam, and in Italy, in Rome. And Melbourne, did I say, yeah, Melbourne, Australia.

So I'm feeding these—these are shops, actually. You know, this is interesting. This lowbrow thing of which I'm sort of a part is being marketed in shops rather than in galleries. Or gallery shops, it goes both ways, so I don't know how quite to describe these places, because I haven't been to a lot of them, but it looks to me from the pictures I see that they have books—have you ever been to a place called the Soap Plant in Los Angeles? It's called Wacko now?

MP: No.

CK: Oh, it's run by this guy, Billy Shire. It's got books, souvenirs, kitsch, interesting stuff picked up around the world and put on shelves for you to look at and buy. And then spaces for exhibitions that are up for a month and then

come down. So it's a mélange of interesting objects that you can purchase when you walk into one of these places. Lots of limited editions.

GJ: Right, it's sort of a boutique/gallery kind of thing?

CK: Yeah, that's a good word, thank you. A boutique gallery, exactly.

GJ: Who are some of the famous people who have collected your works?

CK: Let's see. Oh, God, Mark Mothersbaugh, of Devo, owns something. Chris Stein of Blondie owns something. Grace Slick never bought anything from me, but I've given her some things, so let's put her on that list.

GJ: Okay.

CK: Let's see.

GJ: Any Hollywood people?

CK: You know, there's some Hollywood people, but I forget who they are. I've got to look at this list. I don't really keep up with it that much. I can't think of any actors, any celebrities. I guess I'm not collected by celebrities. I'm more collected by musicians and people in the music industry.

GJ: Well, that's really interesting in itself.

CK: Um, let me think if there's an actor . . . I just can't pull one out of my head right now, but I'm sure there is one, because in Santa Monica, the Copro Nasen Gallery peddles my work, and I guess some actors have come in there and bought something, I've been told. But I can't remember

who they told me it was.

GJ: Have you ever done any album art?

CK: No. I'd like to do some if anybody wants to. I've seen some of my stuff has been appropriated by people that do raves: cards that have some of my grenades with blue and white on them that have been manipulated in such a way to make them look like it's rave art. I've seen that happen. These kids that are mining the internet for imagery and sometimes they happen onto my stuff, and it gets turned into advertising for events at clubs. I've seen that happen. But nobody has actually come to me and said, "Hey, we've got a concept album we want you to help us illustrate." Nobody's ever done that.

GJ: I first encountered your work in a volume on Pop Surrealism, I believe.[5]

CK: That was the first coffee table [book] ever written about this movement. And it was going to be called "lowbrow art," and Mark Ryden didn't like the derogatoriness of that "lowbrow" name, so he insisted if he was going to be in the book, that the authors should call it *Pop Surrealism*.

And it was published in Seattle. It was written up by Kirsten Anderson. That was the first book about this movement, and there's been more since. I can't remember the names, the titles of the other books, but she put me in it because I'm a local guy, and she's got a gallery here, and she wanted to get involved in lowbrow art, and I was making it.

GJ: Well, yeah, so that's how I first knew your name. And then around 2006, I sold a Savitri Devi book to you, and

[5] Kirsten Anderson, *Pop Surrealism: The Rise of Underground Art* (San Francisco: Last Gasp, 2004).

that's how we first actually got in touch.

CK: Oh, when you were down in Atlanta?

GJ: Yeah.

CK: And I bought a book from you, eh?

GJ: Yeah.

CK: Okay. Yeah, I was interested in Savitri Devi through my friend Adam Parfrey that runs Feral House Books. He introduced me to her—what's that one about the Sun?

GJ: *The Lightning and the Sun.*

CK: Yeah, I just thought that was wacky. [Laughs] Hitler as Akhenaten, right?

GJ: Well, Hitler as an avatar of Vishnu.

CK: Oh. But where does Akhenaten, the Pharaoh, come in?

GJ: Well, Akhenaten comes in as an exemplar of the Man Above Time, as opposed to the Man Against Time.

CK: Oh, okay.

GJ: He's the impractical spiritual teacher who's ultimately ground down by the system. Whereas Hitler, Hitler had enough mastery of the world that he could actually fight and try and change society, resist the downward course of decadence. Whereas Akhenaten just got steamrollered by it in the end.

CK: Oh. And so Hitler was the avatar of—what's this business about the Kalki avatar, then? Isn't that supposed to come at the end of the Kali Yuga? Why are they calling Hitler the Kalki avatar?

GJ: Well, you see, that's a misnomer. She believed that Hitler wasn't the last avatar, but he was the penultimate avatar.

CK: Oh, second to the last.

GJ: Yeah. David Tibet wrote this song, "Hitler as Kalki." Either he disagrees with her view, or he just didn't understand what Savitri Devi was saying. And I guess Miguel Serrano describes Hitler as the last avatar. But anyway, that's an interesting topic.

CK: Well, Adam Parfrey is an interesting guy, and he's had his thumb on all kinds of offbeat stuff for most of his career, which is about twenty-five years of publishing, now. And he introduced me to Savitri Devi's *The Lightning and the Sun*. Then I would run into those copies of that book in used bookstores, and that's how I heard about it at first. And I thought it was kind of a wacky idea about Hitler being an avatar or a Pharaoh, you know, I can't remember exactly. You know more about it than me. That's probably why I ordered the book from you!

GJ: Right.

CK: But why don't we tell them about my big trip to Savitri Devi's friend in Arunachala, you know. That sent me packing when I found her. [Laughs]

GJ: Yeah, well, I gave you the name and address of this woman who knew Savitri Devi, who lived in Tiruvannamalai. Her name—she's dead now—her name was Miriam

Hirn. And I wrote to her and said that you were going to be traveling there, and maybe she didn't get the letter or something. [Laughs]

CK: I heard from her too, you know, once I was in India.

GJ: Yeah.

CK: I was in Trivandrum, and I wrote to her, and I told her that I'd like to have a meeting with her, and I did get on a bus and I traveled all night to try to get to Tiruvannamalai. Is that the name of the town where she was?

GJ: Tiruvannamalai.

CK: Tiruvannamalai, thanks. I'm terrible. I've been there, but I can't pronounce it.
 She wouldn't see me. There was a man with her; they wouldn't open the door; and he shooed me away with his hands, and then he threw his hands in the air, like, "I can't help you. She doesn't want to see you."

GJ: She can be very exasperating. She had a certain paranoid streak to her that could be very exasperating. She died almost exactly two years ago. She died on April 16th, 2010, and I didn't discover it until March of this year.

CK: Are they both, Savitri Devi and she, disciples of Ramana Maharshi?

GJ: Well, Savitri Devi never really followed Ramana Maharshi. She respected him tremendously and thought he was a genuine holy man. But this woman Miriam Hirn was very much a follower of Ramana Maharshi. She was a civil servant in the French embassy in New Delhi. And that's how they met, that's how Savitri Devi met Miriam Hirn,

and they got to be good friends. This was in the 1970s. And even before they met, Miriam Hirn was travelling from Delhi to Tiruvannamalai to spend time at the Ramana ashram. And after she retired from the civil service, she thought she'd go back to France, but then she quarreled with her relatives in France, and she just decided to go back to India. And so she lived in Tiruvannamalai on and off for the rest of her life.

Primarily she lived there, and she would go to the ashram every day. And when I visited her there in 2004, we would go to the ashram, and it was a genuinely spiritual place. It was really quite a beautiful place. And one day we took a trip to Pondicherry, and we went to the Aurobindo ashram. And you couldn't imagine a greater contrast between the two institutions, because the Aurobindo ashram is just a giant gift shop and bookshop, and they're just hawking things. Every square inch of it is full of merchandise for you to buy. I think that probably has a lot to do with the fact that the mother of the ashram, Mirra Alfassa, was a French Jewess: she certainly applied her people's business acumen to running that ashram.

CK: Was Aurobindo Alzheimered out at the end his life? That's what I heard. That she took over and sort of kept it a secret that he had lost his faculties.

GJ: Right, that's entirely possible. Miguel Serrano has an absolutely wicked description of the Aurobindo ashram in his book *The Serpent of Paradise*.[6] And Savitri Devi, in her last book, *Memories and Reflections of an Aryan Woman*, describes the contrast between those two ashrams. I'm borrowing her language, but it fit perfectly when I got there,

[6] Miguel Serrano, *The Serpent of Paradise: The Story of an Indian Pilgrimage*, trans. Frank MacShane (London: Routledge & Kegan Paul, 1974), chapter 25.

just to see the difference. I guess the Aurobindo ashram is basically the biggest landlord in Pondicherry. They own, like, a third of the town now. They kept buying things up. They probably loaned money out and then foreclosed.

CK: I went to Pondicherry, I was impressed with its cleanliness, and I bought a croissant there. It's very French. I didn't go to the ashram, though. I didn't make it there.

GJ: Well, they probably owned the place that sold you the croissant. But it's so funny: I knew I was in Pondicherry because suddenly we had gone from twisting, chaotic Indian streets to a Cartesian grid!

CK: Yeah, exactly. [Laughs] It felt like home, didn't it?

GJ: Yeah, sort of.

CK: I bought a really nice little statue of Gandhi from the hotelier who put me up. I saw in his foyer, and I asked him if I could buy it from him, and he said, "Sure." So it's my only souvenir from that trip.

GJ: I got this beautiful statue of Vishnu and his avatars when I was in India in 2004, and I went to various really nice shops where they sold sandalwood carvings and things like that, which they assured me were all from trees that were cut down before they were banned. Of course, they were probably lying. But anyway, I went there, and I kept asking for an image of the Kalki avatar, and nobody had any images of Kalki. And finally I asked this old Brahmin gentleman why they didn't have any images of Kalki. And his response to me was so charming: "But Kalki avatar has not come yet!" [Everyone laughs] "How can we have an image of him if he hasn't come yet?" As if all these other images were from life, right?

CK: Right, exactly. Did you happen to get into any Nicholas Roerich? Did you look into his life?

GJ: He's a really interesting character. I've seen his paintings, and I've done a little reading, but I don't know all that much about him.

CK: I don't, either. I went to his center in New York City and looked at his paintings and his son's paintings. Apparently, he worked for the Ballet Russe, as a set painter.

GJ: Right, didn't he paint the sets for the *Rite of Spring*?

CK: Yeah. And then he moved to India, and he was living in the foothills of the Himalayas for years. Who was that musician that wrote *The Way to the Labyrinth*, remember? He was a French musician, and he wrote a book about India and he went to visit Nicholas Roerich.

GJ: Oh yes, that's Alain Daniélou.

CK: Yeah, exactly. I thought that was a good book.

GJ: That is a great book. I liked that book tremendously.

CK: Yeah, me too. I recommend that book for anybody that's thinking about visiting India, or anybody with nostalgia for the India of the last century, the tail end of the twentieth century.

GJ: Right.

MP: I really liked your "Forgiveness" line of cosmetics.

CK: Oh, yeah.

MP: I wonder how that went over, if you got a lot of flak from that, and also how well they sold, and if you're still making them.

CK: I haven't gotten really any flak over them, and periodically I do a little installation where I've got the soap, the perfume, and the advertising that goes with it on display. It continues to pique people's curiosity. It's not a big seller because of the swastika, of course. Nobody wants swastikas in their homes, because it reflects on them, they think. Or, they think their neighbors and friends will misconstrue the symbol and accuse them of something. So no, I can't say it's a big deal for me. But I continue to have people buy it from me, every once in a while. You know. I'll sell them a bottle of Forgiveness. [Everyone laughs]

I had a custom set made by an essential oils salesman in Los Angeles. And I told him I wanted the scent to be "Blood on Snow." And he said, "Well, that's a challenge." And so he sent me back a variety of scents that he had come up with, and I chose one. There really is a Forgiveness scent. But I'll tell you what, I've never smelled blood on snow, and this isn't it, for sure. [Laughs] But, it's a nice smell. It's got vetiver in it. Lots of vetiver.

The soap is really porcelain. I've made bars of real, glycerin soap, but it's too much trouble for me to go and make a bar—it's just as easy for me to make a bar of porcelain soap as it is to make a bar of real soap. And this is terrible, but I can ask more money for porcelain than real. [Laughs]

So I stick to the porcelain. You got to buy this fake soap from me, if you want a bar of Forgiveness.

MP: What inspired that idea?

CK: I was in Sarajevo one night with Peter Mlakar, who's the official orator of the Laibach band. And he's also the head of their Department of Pure and Applied Philosophy,

NSK, and he was just drunk as the Lord.

We had been to a club, and we were going home to where we were being put up. It was up this steep hill, above the bombed-out Winter Olympic Stadium, just torched, and then next to that was a maternity hospital, and that had been torched. So we were overlooking the ruins of these two facilities, from the top of the hill, in the full moonlight, in the snow. If you can imagine. The cab couldn't get up the hill, because the road was all icy. So he let us out, and we were walking up to where we were staying. And he turned around and looked at this devastation all around us, and said, "Ah, the smell of blood on snow. It's so Tolstoy, I love it! If I could create a scent for the twenty-first century, I would call it 'Forgiveness.'"

And I remembered that, and when I got back, I went to work on creating a line of cosmetics that was based on that offhanded remark, a remark that was full of irony. The night that he made that we were in Sarajevo.

I think I got that quote right. I might've had it wrong. But essentially, he was just saying that the devastation required a new perfume, and it should be called "Forgiveness."

GJ: I love your snuggle bunnies, and your various rabbit-themed pieces.

CK: Frank Kozik is a San Francisco lowbrow artist who started out as a poster-maker for rock'n'roll concerts. He graduated to toys now. He puts out a lot of plastic toys that are made in Japan and China.

He did this thing called a "dunny," a smoking bunny, that's kind of pneumatic-looking. It has no features except for a cigarette stuck in its mouth, two ears, and this crazy body that doesn't have any detail. It looked like a blimp.

And he was coming to town for this exhibition at the Roq La Rue Gallery, and Kirsten Anderson, the director

there, wanted to put us together. I thought that was a good idea because Frank had used a lot of Nazi imagery in his rock posters, these Day-Glo rock posters which came after the psychedelic rock posters from the Haight-Ashbury. They were just as great. A completely different sensibility, but they were just as graphically wonderful.

So I said, "Yeah, sure, I'd love to show with Kozik." So he came to town. He had a book he was flogging. And he had a hundred little robot Hitlers that he had made out of plastic. He had some company in Japan do them for him, and they were lined up ten deep on a wall, ten high and ten deep. And these kids were bringing these toys that they had gotten from this shop in New York that sells artist toys, called "Kid Robot," that manufactured the smoking bunny.

I call it a "dunny," but that's not right. A "smorkin"! He calls this thing a smorkin. They wanted Frank to autograph it. So I knew he was coming, and I wanted to do a smoking bunny myself. I had a bunny mold that I had found in an abandoned ceramic hobby shop, and I just stuck a cigarette in it.

It's an homage to Frank Kozik. For some reason, this damn thing has taken off. The two things that I sell the most of are hand grenades and smoking bunnies. [Everyone laughs]

GJ: And I've seen the combos, the bunny/grenade combos.

CK: Yeah, I put a grenade in the bunny's hands. And sometimes the bunny has a hypodermic needle—that's the "junkie bunny." And sometimes it's just sitting there, smoking on its haunches. People just seem to like it, so I've sold not a "whole lot" of bunnies, but enough for me to be able to call it one of the more popular items that I've come up.

I stole the thing from Frank Kozik, I'm sorry to say. It's not me, it's Frank.

GJ: Well, it's an homage, not a theft.

CK: Yeah, right. It was an homage.

CK: Thanks a lot for asking me to participate. I like the *Counter-Currents* website, and I'm honored to be affiliated with it. I like your books too, I just read *Revolution from Above*.[7]

GJ: That's from Arktos.

CK: Oh, is that it? Sorry, then, Irmin Vinson's *Some Thoughts on Hitler*.[8] I read that. I thought that was great. And Kerry Bolton, I told you, I think he's really good.

GJ: I think he's really good. We're bringing out a book of his very soon, *Artists of the Right*. So, I'm working on that as we speak, practically.

CK: Oh, good. Because I think he's one of the best explicators of the political direction that I find myself in, living today. If I could try to explain how I think, and why I'm thinking the way I am, I would direct people to Kerry Bolton. He's done a really good job of explaining things, I think.

GJ: I agree.

CK: I consider him a guru. You know, I've told you this.

GJ: Yeah.

[7] Kerry Bolton, *Revolution from Above* (London: Arktos, 2011).

[8] Irmin Vinson, *Some Thoughts on Hitler & Other Essays*, ed. Greg Johnson (San Francisco: Counter-Currents, 2012).

CK: I got in touch with him when he was writing about the Order of the Nine Angles. I was investigating Satanism. Have you ever heard of the Order of the Nine Angles?

GJ: Yeah, I don't know much about it.

CK: Well, they were supposed to carry out these cullings, where they would grab people and sacrifice them. It's an urban myth. But these guys are supposed to be the baddest of the bad black magicians practicing sorcery today. I wrote to Kerry Bolton because he had some information that he was selling about them. And then I started ordering some of his other stuff, and I'm happy to see him getting more exposure over the internet, because tracking him down was a bit of a task in the old days before the internet.

GJ: Oh, yeah.

CK: You know he's there in New Zealand, on that beach. You'd send him the money, and then you'd get this stuff from him, and it was always interesting. I just love going to, *Foreign Affairs*? That blog he writes for, what's the name of that one where he's commenting on geopolitical stuff as it happens?

GJ: Yeah, the *Foreign Policy Journal*?

CK: Yeah. *Foreign Policy Journal*. I go there to see what he's put up, regularly. And every time he puts something up, I'm usually impressed with it.

GJ: I agree, he's done a lot of great things for us about the color-coded revolutions around the world . . .

CK: Yeah, exactly.

GJ: . . . the Twitter and Facebook insurrections in the Near East, and so forth.

CK: All of that stuff. People should be reading him instead of Noam Chomsky, for God sakes.

GJ: Yeah, he's our Noam Chomsky. [Laughs]

CK: We should bring him to the United States and have some Kerry Bolton events, I think.

GJ: We'll definitely talk about doing that. It's a bit expensive to get somebody from New Zealand, but—

MP: Has he spoken at any conferences overseas?

CK: That I don't know. I don't know too much about the man.

GJ: I don't know, either. If he hasn't, it would be great to be the first people to roll him out.

CK: Yeah, well, get in touch with me if you want some financial assistance. And if I've got some extra money, I'll put it into bringing him here.

GJ: Well, that's fantastic.

CK: I'd definitely like to meet him.

GJ: We'll take you up on that. We really will.

CK: Okay, let's pass the hat and get him here.

GJ: Well, Charlie, this has been a really enjoyable conversation. Is there anything you want to say just at the end? Are

there any questions we should have asked you that you would like to answer before we go?

CK: I don't think so, other than I wish I had more of a vision for artists in your movement. I don't really know what we can do, except just get more people exposed to the work that we like. And maybe that'll lead to some kind of transmogrification from then to now, and we'll get some of the craftsmanship and ideas that we like so much back into contemporary art.

You know, artists don't learn from nature so much as from each other. So the trick is to get people that are involved in art and want to be artists and appreciating art to broaden their horizons by introducing the names and works of these people that are overlooked by history.

GJ: Yeah, well, I think we've made a good start with that in this very conversation. So thank you so much.

CK: Well, you're welcome.

A Toast & an Oath

February 26, 2012

Charles Krafft regularly attended *Counter-Currents* Retreats that were held in Santa Cruz, California from 2011 to 2015. The Retreat of February 25–26, 2012 was particularly memorable, with an electrifying keynote address by Jonathan Bowden delivered less than a month before his death. We would end our retreats with each guest offering a toast and an oath: a toast hailing something good and an oath to do something good and report on it at the next retreat. This is Charlie's toast and oath from February 26, 2012. I would like to thank Hyacinth Bouquet for this transcript.

I toast all the participants in the retreat, and congratulate you on your perspicacity, and also on your comradeship. I enjoyed, most of all, the repartee and what goes on outside of the general panel discussions and presentations, when I get to talk to you individually and trade information. That's the most valuable thing, for me, when I come to these. So thank you, for being here, and for sharing your knowledge with me.

As an artist, I'm sort of constantly looking for a label to define what I do. This last year, I've been kind of preoccupied with seeing if I can't come up with a name to describe an art movement that would encapsulate our ideas, and our hopes, and our goals.

So, I pledge to continue to refine my search for a key couple of words that will be able to help us move our ideas out into the greater population, using the visual arts, of which I am a tradesman. And if I can do this, I'll report

back to you in six months or a year, and let you know what the name of my new movement is.

I don't want to bore you, but in the course of trying to find this name, I've gone back before World War II to investigate the Vorticists and the Futurists, who sort of embody nationalism before it was swept underneath the carpet.

I'm serious about this, and I'm a pretty good wordsmith, and maybe with help from fate, I can come up with a name for an art movement for us.

An Artist of the Right

August 26, 2012

Charles Krafft returned to the next *Counter-Currents* Retreat, which was held in Santa Cruz, August 25–26, 2012. On the morning of August 26, Charlie did a talk called "An Artist of the Right." This is the introduction and Q&A from that talk. The main body of the talk was a slide presentation, but we could not include it because we don't have access to the images. We will, however, make the audio available if someone wishes to meld it with images to create a documentary about Charlie's art in his own words. I would like to thank Hyacinth Bouquet for this transcript.

Greg Johnson: Our first guest today is Charles Krafft. He is an artist from Seattle, and someday he will be appointed Armaments Minister of the North American New Right. I give you Charles Krafft. [Applause]

GJ: The last time we got together, you talked about how you were trying to come up with a name for the kind of art that you do, and how it fits in with your sort of larger political, historical project. Did you come up with that name? How would you describe it?

Charles Krafft: Well, I'm the only person. How can one guy be a movement? I don't know anybody else that thinks like I do or has gone politically to the Right as far as I have. When we were discussing this the last time, I told you that "National Futurism" was the name that I liked, but I don't think that's going to go anywhere. And I haven't come up

with anything since I talked to you about this, six months ago. You're gonna have to give me another six months and hope for the best.

Question from Audience: Are you a follower of Guillaume Faye's ideas? I'm reading one of his books about Futuristic Nationalism [*Archeofuturism*], or whatever it was.

CK: National Futurism?

Question: Alright, National Futurism. What brought you over to that?

CK: Oh, well that's a completely different story. I'll tell you right now, I drifted into "National Futurism"—for lack of a brand for what I think I'm doing—through revisionism. The whole thing started with a story about Archbishop Valerian Trifa, who was the Romanian Orthodox leader of an immigrant community in Grass Lake, Michigan. He was the first "Nazi" war criminal to be deported from the United States.

I read about him in a pulp paperback account of Nazis in America, and I thought, "Wait a minute. This guy can't be that bad, because the author is saying this Romanian fellow is even worse than the worse Nazis were." I ended up doing quite a bit of research and going to Romania twice, looking for evidence that might clear his name; and I'm still working on it.

It started off as a revisionist quest for the truth and ended up as a kind of political worldview.

Question: Were you ostracized by fellow artists?

CK: Yes. I'm a bad guy. I get people on my Facebook page—I've had people write to the newspapers telling the critics of the papers I'm a Holocaust denier and a bigot.

There are other people that were following my career when it was more metaphysical, and less political, that are completely shocked at the things I say to them, because, I don't really hold back. I don't have that much to lose. I'm self-employed. They can't fire me from my job because I'm the boss.

Yeah, I'm having a lot of trouble. I don't really know how to deal with it really, because it's just something I'm going to have to put up with. It hurts, to be quite frank with you. I get my feelings hurt. It really hurts when some friend of mine tells me that they think I'm a "hater." It just happened before I came down here. Some artist friend of mine wrote to another artist, and said that I've gone off the rails here.

I'd like to be able to sit down and explain this to these other artists, comrades of mine, that are in my community and that I've shared part of my life with. I've realized that I can't do it. It's just too much information at once for these people, because it took me a decade to get where I am. I've studied.

And artists are built-in cultural Marxists. It's just sad, because anything that comes down the pike that's extremely liberal or utopian, they're going to go for. They think they're being rebels and radicals, and they're critiquing the culture. They're not! They're mimicking what the culture is all about.

In the profession of the arts, if you want a job as a teacher, or if you want to apply for grants from any funding organization, you're up against a brick wall if you begin to explain some of this stuff. It's okay because I've always felt on the outside anyway. Even when I was less Right than I am now, I felt alienated from the mainstream culture anyway. That's why I became an artist, I guess, because I didn't fit in.

But this business about being accused of bigotry, and some kind of malicious evil, through symbolism, it's ridiculous. I don't like it, but at the same time, I'm hurt by it. So,

I don't know what to do.

Question: Well you can tell them you're breaking their monopoly. The Left no longer has a deadlock.

CK: They do! That's the problem.

Question: You are breaking it.

CK: I'm trying to, but I'm out here all by myself, and it's really lonely. I wish there were others.

GJ: That's why it's so important for people who became established in the field, like you have, to be out there. Be open. Because one of the things that we want are to have role models that other people can look to. In the past, in the twentieth century, especially the first half of the twentieth century, a lot of the greatest artists in the West were Rightists. Salvador Dalí, he was a right-winger. Literature: a lot of the great literary figures, especially literary modernists, were Rightists, and we want to bring that back.

This is why I call this session, "An Artist of the Right," because there is one working today, and there will be others. There will be others, in the future. So, you're not the last of the Ezra Pounds, you're the first of their return.

CK: Right. [Applause] Thanks a lot.

Let me just say that there are artists on the Right. They're graphic artists; they're not fine artists, as far as I know. We discussed this about the neofolk movement and some the graphics that are coming up on the packaging of this music, and in the field of music they're making breakthroughs.

But in the visual arts, I have to say, it's a monopoly. The liberals have a monopoly on it. You can't touch the Holo-

caust, of course. The whole bit. I'm in trouble for the Holocaust. That's what gets me in trouble. Never had any other issues as sensitive as that one, with people in the community.

Question: [Most of the question is inaudible, but the questioner visited a former German concentration camp] "they showed us the gas chamber . . . Nobody came out and said explicitly, 'This is a death camp.' But, it sure was implied."

CK: There was a sign there, the shower room that they call a gas chamber, had a sign that said it—and I saw it. I got a snapshot of it, never used. I believe that it was a movie set for George Stephens, who was there to document the liberation of the camp.

I've been doing quite a bit of research on the Holocaust as a psyop. I've been to the British National Archives at Kew Gardens and gone through Sir Bruce Lockhart's papers. And I found out that William S. Paley, of CBS, and C. D. Jackson, who was the editor of *Life*, *Fortune*, and *Time*, were in this special, exclusive, and secret black propaganda unit set up by Sir Bruce Lockhart.

Revisionists have done the forensics, and that's fine. But nobody's talking about this in the terms of intelligence. I wish that somebody would really look hard at the intelligence: the OSS[1] and the PWE[2] and some of these other intelligence units. The Signal Corps (USASC). I think those guys were involved in this, too. George Stephens was one of them. Billy Wilder was one of them. And Alfred Hitchcock. They were manipulating photographs, film. The first time that film was ever used as evidence in a court case was Nuremberg. And those films were phony.

[1] Office of Strategic Services (USA)
[2] Political Warfare Executive (UK)

Counter-Currents Radio Interview

March 12, 2013

This is Charlie's second interview with Counter-Currents Radio. It focuses primarily on his "outing" and the aftermath. I wish to thank the transcriber, who must remain anonymous.

GJ: I'm Greg Johnson, welcome to Counter-Currents Radio. My guest today is Seattle artist Charles Krafft. Charlie, welcome back.

CK: Thank you, Greg. Good to be back.

GJ: Well recently, Charlie, you've been at the center of some controversy over your art. Now some time ago, you started painting swastikas onto Delft porcelain, and, I want to know, do you have something against the Dutch?

CK: [Laughs] No! I began painting on plates. And the plates I started to paint after I learned how to be a china painter were called "Disasterware." And I was concentrating on natural catastrophes, which would be fires, floods, and earthquakes. Airplane crashes and such; train wrecks. And then I drifted into sociopolitical catastrophes, and because I was working in the blue and white on china, I thought "Well, I'll do an occupation of Holland picture on a plate." So the first swastika I ever painted was referring to the German occupation of Holland.

GJ: About what year was that?

CK: About 1991.

GJ: 1991. Okay. I noticed these little Dutch windmills with swastika blades that say "Von Dutch" on them.

CK: Right.

GJ: This was my theory, and I didn't have any way of confirming it with you because you were in India at the time. But my theory was that that was kind of a visual pun on the name Von Dutch, with the Dutch Delftware and the windmill, and then the "von" would be the swastika which is German, with the swastika sort of associated with the Germans. Was that a correct hypothesis, or was I way off there?

CK: No, that's half-correct because . . . my drift into ceramics was a result of me not knowing how to paint a Dutch Delft tile portrait of Von Dutch to send to him as a token of my esteem. So I had to take a class from some hobby crafters in town that I got in touch with who showed me how to paint on a ceramic surface and have it be permanent. So you're right about the Von Dutch / Dutch Delft connection. It's a play on words.

But the swastikated windmill was made during a residency in Hertogenbosch, Holland, where I found a bunch of Delft kitsch molds in the mold room that had been donated by a kitsch factory. And I had another project going which I couldn't start, so I began to play with some of this airport Dutch kitsch that you might pick up in the Schiphol Airport or in a Dutch souvenir store somewhere in Dam Square if you were in Amsterdam. And I began to tweak those objects. There was a cow creamer and windmills and some, I think, some vases, that I found.

So when I got the windmill mold, I thought, "Well, what can I do with this?" Well, the windmill blades were already

kind of swastika-looking, I just re-sculpted them. And started putting swastikas on windmills.

GJ: And you also did versions with the Laibach symbol.

CK: Yeah. It's the same windmills except I used the Laibach cog logo. That logo is the "Malevich Black Cross," and the black cross, that's their logo. With a cog around it.

GJ: Which is a kind of commie, East German kind of feel thing as I interpret it. Right?

CK: Ah, no. It actually refers to the Nazis and the Arbeit Work Units. Do you know? They had a swastika inside a cog.

GJ: Oh really? I didn't know that. That's interesting. Because I do know that there was an East German image that used a cogwheel. Maybe they were just riffing off the Arbeitsdienst thing. That's really interesting.
There's also this famous Hitler teapot which is in San Francisco—the *Hitler / Idaho* teapot—and again, whenever I look at that image, I have to ask: Do you have a beef with the people of Idaho? Is there some issue that you've got here that you're putting their name on a teapot with Adolf Hitler? I mean, how did the *Hitler / Idaho* pot come about?

CK: Well, because the Aryan Nations Church—Richard Butler's Aryan Nations Church—and Paul Greitz's all-white gated community project were all being written about a lot in the Seattle newspapers. So Idaho became kind of a . . . when we thought about Idaho, we thought about Nazis. That's the way they were painting the State of Idaho in our media here. That all these white supremacists were moving to Idaho.

GJ: Right, that makes sense. I was just curious about that. So just to repeat. Your first use of the swastika was 1991.

CK: Right.

GJ: What percentage of your ceramic output, would you estimate, contains images of swastikas, or images of Adolf Hitler, or anything else associated with the National Socialist period?

CK: Less than ten percent.

GJ: Okay. And let me ask you—I know that you are an artist who responds to commissions. You're a businessman as well as an artist, and so if there's a particular market for certain kinds of things, you're going to do more of these things than say other things that are less in demand.

What percentage of your Hitler or swastika images are responses to actual commissions?

CK: Maybe . . . five percent. One to five percent. I don't get that many commissions for . . . people are . . . I've gotten commissions for the Hitler Teapot. That's kind of a semi-popular thing that I do on demand.

People have seen the picture on the internet in various places, and they want to know if I'm still making them, and whenever I get asked if I am still making them, I say "yes," and I tell the potential client that I will make them one.

So, that is always in production, but I don't sell a lot of those, and I don't sell a lot of other items that reference the Third Reich history or imagery because they're unpopular and unsalable.

GJ: Really? That's interesting.

On the assumption that most of your patrons—most of the people who may give you commissions—are not going to be self-identifying, but still, do some of them identify themselves as someone who is interested in this stuff? Do you have people who come to you and say, "I'm a Jewish collector and I really love your Hitler Teapots." Or . . .

CK: Yes! I had a Jewish collector ask me to do a Hitler Teapot in blackface.

GJ: I've seen that. Yeah, that was pretty impressive.

CK: This was a request that I probably would not have stumbled on myself, as an idea. And when I got done doing it, I was pretty pleased with myself, because I turned it into a comment on the Insane Clown Posse. So, it turned out pretty nicely for me. The client liked it a lot until he found out I wasn't making ironical comments about the Third Reich.

Because—this is before the scandal—he was visiting my Facebook page and noticing some of my postings, and especially some postings by a stalker I had there that was a very crude anti-Semite, whom I should have blocked earlier on, but allowed to continue to splatter my timeline there with attacks on posters there that he felt should be taken to task for not knowing enough about things.

GJ: So, do you think you get more commissions from Nazis or Jews of Third Reich-related stuff? Because my intuition is that if somebody is a really sincere and pious Nazi, he's not going to want to serve tea out of a pot shaped like Adolf Hitler's head—that seems a bit irreverent. Or even just a bust of Hitler in Delftware, that doesn't seem particularly reverent.

Do you have any impressions on the percentages of people who are actually commissioning these things?

CK: The people who are actually commissioning them are neither Nazis nor Jews. They're Gentiles, for the most part. A lot . . . not a lot of my clients . . . they don't identify themselves as anything, although . . . I do know that sometimes when someone is a National Socialist, I mean not a National Socialist, but a maybe White Nationalist, put it that way—I mean they might identify themselves as that.

But, Nazis, I mean, there are no Nazis. I don't know any Nazis. Nobody is identifying as a National Socialist anymore. There are some people on the internet—National Socialist information websites—but there's no organized National Socialist groups that, really, I'm aware of.

GJ: Well, there are ones out there on the web that claim to be that but, of course, anybody can create a website. The recent revelations, for instance, about the Norwegian Defense League, which was painted in the Norwegian press as this extreme Right-wing, racist group, and turns out it was being run by a combination of anti-racists, anti-fascist activists, and the Norwegian secret police, makes you scratch your head and wonder "Are there any real Nazis out there on the net, or these all people working for the government and the opposition trying to entrap people by going and saying 'Hey! Finally, a Nazi website that I can get behind!'?" So, yeah, there are questions that you could raise about that.

CK: There's answers, too, because it's been proven that some of these American Nazi organizations—they're called "Costume Nazis" in the community, because they like to wear uniforms—they've been exposed as honey-traps.

I mean, it's happened repeatedly. There's no speculation about the fact that the government is setting up honey-traps to surveil people with, I guess we'd just say, extreme Right-wing opinions about things.

GJ: Right. You said you first used the swastika in 1991. When did you first become interested in the Holocaust and Holocaust revisionism?

CK: Around the same time. And it was a result of a residency I did in Slovenia—Ljubljana, Slovenia—with the NSK collective of which the band Laibach is a part.

So, they were involved in this postmodern *bouillabaisse* of symbols. Symbology and iconography. Catholics, Nazi Kunst, and Soviet Socialist Realism—and they would mix this up in a salad and present it, and you got this totalitarian imagery—but it was balderdash, you know?

I don't know how else to explain it. Their rhetoric sounded very fascistic and totalitarian, but when you actually went back to look at it more closely, it was just a collection of tropes that they had collected from everywhere and repackaged as speeches and manifestos, but it didn't really make much sense. They're making a comment on "the state." And what they said was they were holding a mirror up to "the state" by being more of a state than "the state." They were sort of . . . it was all hyperbole. Fascist, Nazi, and Communist hyperbole. Are you following me?

GJ: Yeah, yeah—what year was this?

CK: Well, this was when I actually went to Slovenia to work with them on a collaborative project that was sponsored by the ArtsLink Citizens Exchange Council [now CECArtsLink] which is a nonprofit in New York City that puts Eastern European artists together with American artists and vice-versa. They send us to Eastern Europe for collaborative projects and bring Eastern Europeans to the United States to work with artists.

So, that's when my art sort of took on this political look, because I was fascinated with the NSK theory which they actually worked out called Retroavanteguardism. It's sort of

academic, and I started to understand it as a postmodern comment on the tyranny of, I guess, globalism.

GJ: Right. So, your own work has a kind of a range of images that are drawn from—how to say—the sort of "totalitarian rogues galleries," the "Axis of Evil" that was put forth by the Bush Administration. Because you have images of Ahmadinejad of Iran, you've got images of Kim-Jong Il in North Korea, so you're sort of using that same range of totalitarian boogie-man images that the NSK people were using. Is that a fair characterization?

CK: Ahh, yes, that's fair. Fair enough, except that the NSK group concentrated on pre-World War II boogie-men and I was looking for post-World War II, contemporary boogie-men.

They [the NSK] had a theory about the avant-garde being co-opted by capital and power as the war, the Second World War, started up. These new artistic genres like filmmaking, and sound, and painting—modernism in general—became part and parcel of their propaganda programs. And the idea of . . . this utopian trajectory that modernism, they thought—Eastern modernism—let's put it that way. Russian Constructivist and Malevich's Supremetism. Wasn't he a Russian Supremetist?

GJ: I really don't know.

CK: The avant-garde Russian.

GJ: Yeah, I know his work, but I don't know what his politics were.

CK: It's not racial supremacism but its called "Supremetism," I think. Malevich. It's a kind of a metaphysical thing. He was inspired by Madame Blavatsky.

GJ: Oh really? That's interesting.

CK: Yeah, it is interesting. Maybe I'm mispronouncing Malevich's philosophy, but in any event, these guys thought that the trajectory of modernism, because it leaned east, to Russia. Okay, they're in Slovenia, Eastern Europe. They're inspired by the Russian avant-garde. They thought that utopian trajectory modernism was on, for them, had been derailed by the war, so they wanted to figure out—they wanted to go back to re-examine the trauma of World War II and see if there was some way to get modernism back on track, you see? So, anyway, I liked the way they mixed and matched symbols. And it was very powerful to me. And I understood that they weren't promoting Nazism, Communism, Catholicism, or any -ism at all except postmodernism, you see?

And that's how I started to look for "clichéd evil" to incorporate into my ceramic work, because I thought it was interesting who's deemed the next Hitler, for instance. So, Ahmadinejad and Kim Jong-Il; they always have to have a boogie-man to go after. And I was interested in these boogie-men; and then de-mythologizing them by satirizing them. Turning them into teapots . . .

GJ: . . . and Chia Pets.

CK: And Chia Pets, and listen, piggy banks . . .

GJ: Oh, that's even better!

CK: . . . and [laughs] and also just busts and Toby Mugs, you know, you have can it as a mug, a piggy bank, a Chia Pet, or a teapot. Or you can have it as a bust, if you really like the guy. Whatever.

GJ: And want it in blue and white. So, one of the things

I'm concerned about is the big controversy started on February 13th in *The Stranger*, which is one of these free, alternative, urban weekly publications as I understand it. And their arts writer, Jen Graves, wrote a piece with a really, really concise and snappy title: "Charles Krafft is a White Nationalist Who Believes the Holocaust is a Deliberately Exaggerated Myth"—you can almost hear her breathlessly tattling to the world. And in there she makes the argument that your use of an image like the swastika or putting Hitler's head on a teapot is an expression of hostility toward Jews, and the *prima facie* evidence that you're hostile to Jews is that you're interested in historical revisionism about World War II, more broadly, and also, specifically, the Holocaust. And it occurred to me that while if you're using these images before you really were involved in revisionism, then obviously, her argument doesn't follow. So I was just trying to get clear when you started using such imagery and why. And did that have any connection, at least at first, when you developed an interest in revisionism?

CK: I didn't follow your question because it had a couple of parts, but I think I got the gist of it.
The answer would be that I was using Nazi tropes before I became interested in Holocaust revisionism.

GJ: Okay, yeah, that's what I wanted to know.

CK: Yeah, but I did get interested in Holocaust revisionism as a result of that trip to Slovenia, because it was around that time I picked up the book, *Nazis in America*, by Howard Blum[1] and learned about Viorel Trifa, the case against the Romanian Arch-Bishop, that was ultimately deported from the United States in about 1982.

[1] Howard Blum, *Wanted!: The Search for Nazis in America* (New York: Quadrangle, 1977).

GJ: What happened to him once he was deported?

CK: He ended up in Lisbon, where he died of a heart attack shortly after he had chosen that place to go and live because . . . I don't think Romania wanted him, and the only place he could find to land was Portugal.

GJ: Oh really? That's interesting.
So, 1991, the first time the swastika shows up. Sometime later you became interested in World War II and revisionism. About what year did you start taking White Nationalism, as a political world view, seriously?

CK: Well, I don't think I started to take it seriously until about two years ago.

GJ: That was my impression. Because I remember when I was with you in September of 2009 in Seattle, and we were talking, and you seemed a little skeptical of my White Nationalism. I mean, I am a White Nationalist. I've been calling myself that since 2001. And you seemed rather skeptical, and, not dismissive—you weren't treating me as if I was a leper or anything like that—but it was clear that it was something that was kind of foreign to you in terms of something that you could take seriously. Something you could believe, if that makes any sense.

CK: Well, I hadn't done any reading really about . . . like Wilmot Robertson's *The Dispossessed Majority*; I hadn't read it yet. So I hadn't really been exposed to White Nationalist thinking. I mean I knew that there was White . . . Pierce [William Luther Pierce], you know. The *National Vanguard*.
I was aware of that. I wasn't a member of it. I wasn't a subscriber to any of these magazines, but I did know there was this guy down in [West] Virginia that was organizing a

sort of high-toned White Nationalist book catalog. Which I thought was pretty interesting. I think I even got my hands on one of those lovely book catalogs that he published.

GJ: I wanted to ask this because, when I wrote the first article about this whole thing, you were in India, and I couldn't really confirm certain things. I just wanted to make sure that I was correct in my assumptions on this—and I guess I basically was. *The Stranger* article went viral, it got reprinted in a number of places and other blogs, and media outlets have taken up this discussion.

Are there falsehoods and misleading claims in *The Stranger* article that you would like to identify just so that we can factor these out?

CK: Okay, the major falsehood that was perpetuated by *The Stranger* article is that I've been hoodwinking my patrons. That I've sold this stuff . . . They use this Sandy Besser, he was a Jewish ceramic collector who died and left his collection of ceramics to the DeYoung Museum in San Francisco. It was implied that I sold the Hitler head to him and was laughing up my sleeve as having put something over on this Jewish collector. And that I was doing the same with other people who had purchased artwork from me. Thinking that I was being ironical or satirical when, in fact, I'm not being satirical or ironical and that I'm trying to slip this subversive iconography and ideology into their homes, museums, and galleries. That I'm hoodwinking the public with this.

I'm not hoodwinking anybody! I did not sell that Hitler teapot to Sandy Besser! It was sold to him by a gallery. I had no idea who bought that Hitler teapot until I was notified by the Besser's estate that his collection was going to the DeYoung. So it's not like I even knew the man who bought the teapot.

So, like the idea of this meme, of me laughing up my sleeve at liberals about subverting their art collections to be repeated in the media. Because it's not true. I'm not laughing at anybody. I never did laugh at anybody, and I don't like being accused of this hoax that they're trying to pin on me.

GJ: Right! It seems a little nutty, frankly, to believe that somehow smuggling a teapot shaped like Hitler into a museum is really going to somehow change the political dynamics of the world today, anyway. What, exactly, are they thinking that you're up to? It seems to presuppose that there is some kind of numinous evil, that they can't even put their finger on [both laugh] that's involved in these things. But, they know that they have to act hysterical and run around and talk about maybe smashing the stuff to exorcise all this numinous evil.

CK: They're pre-dating my interest in Holocaust revisionism, which is commensurate with anti-Semitism, you see? And White Nationalism; they're pre-dating all of this so that all of my 40 years of art-making is going to have to be re-examined. And then if there's some subversiveness detected, then it's going to have to be deaccessioned from the museum or taken out of the private collection or the galleries. And I can't be included . . .

GJ: And ritually smashed!

CK: Yeah!

GJ: And "this evil" is so all-powerful and yet so numinous and pervasive that I don't think smashing it could really get rid of it! So, they're in a bind. I don't know what they're going to do.

CK: Well, it's so Fu Manchu. It's so clever and sly and insidious, you see? Because it's coming in under the guise of postmodern irony.

GJ: Right. And its obvious now in retrospect, to these people, apparently, that you really do think that putting Hitler on a teapot with big soulful eyes is a tribute to the Führer, which I just think is insane. But to them, now they look at this and they think, "He's obviously up to something. He's trying to rehabilitate Nazism by putting Hitler on a teapot." It seems rather implausible. But, you know, I think a lot of people, especially gentiles, feel that they just have to play it safe in this context.

It makes me think of two instances of superstition, really. The first was when they discovered some trees in the eastern part of Germany. In the fall, their leaves would turn yellow. And from the air, you'd see a yellow swastika, of yellow trees in the green of the evergreen forest. And, when this was discovered, these trees had to be cut down! Presumably because if extraterrestrials [CK laughs] or something flying overhead would see them, somehow this would inspire a murderous hatred of Jews, or something.

And the other thing was, when it was discovered, that from a satellite that there were some buildings, I think it's on a military base . . .

CK: Oh! I remember that. It was the Naval Headquarters someplace.

GJ: Yeah! I think it's in San Diego. If you look at it from outer space, it looks like a swastika, and, again, they had to spend hundreds of thousands of dollars disguising this, just in case, again, this would inspire extra-terrestrials to hate Jews, or something!

And the kind of hysteria there, and the kind of lack of any concern with plausibility or causality. They just see the

swastika and they start running amuck, acting like clowns and expending money trying to get rid of it—indicates a kind of fear, I think, basically. And a kind of assumption that when it comes to anything connected with the swastika, Jews are just completely nuts.

But, anyway, I want to go onto a few other things.

CK: Greg, you know you can't sell Third Reich imagery on eBay. Didn't they pass a law?

GJ: I don't know if they passed a law, but there are certain rules and certain things get taken down off eBay if they sneak on there.

CK: Right. And especially in Europe. You can't have anything that's militaria, it can't be sold on eBay, or something. I can't remember exactly what it is, but there was a great big cleansing of the internet 10 or 15 years ago of people who were trying to sell Third Reich militaria on the internet auction sites.

GJ: So the main misleading claim, or false claim, in *The Stranger* piece is the idea that you are somehow laughing up your sleeve and duping people and cackling all the way to the bank by getting them to buy these things.

Are there any other false or misleading claims that have been circulated because of this *Stranger* piece?

CK: They've also claimed that my dealers have decided that they are no longer going to sell my work.

GJ: So that's false?

CK: Apparently. I don't know. There's a resale gallery they mentioned where the woman said, "I no longer will take any of his art for resale." But the galleries that actually

deal with my work and deal with me, none of them have informed me that I'm no longer in their stable.

GJ: Well, that's good news. One of the things that very clear about the Graves article is that she's pulling the Saul Alinsky treatment on you. She's trying to isolate you from your friends and from your source of income and brand you as some kind of radioactive hater who needs to shunned by everybody.

And this is the way that they always react to anybody who is even slightly prominent and has a heretical thought or two. My question is: Is it working? I certainly hope it's not working. I certainly hope it's not harming you.

CK: It's working because I'm now on the spot with old friends who have somehow stumbled on this news. And I'm getting emails with lines like "say it's not true," or "read it and weep." And some of them have even sat down to let me know how repulsive they think I am, now that they know that I'm a Holocaust-denying White Nationalist. It's hurtful! It hurts!

GJ: Yeah, I know it's got to hurt. You'd have to have a heart of stone not to be affected by things like that.

So how are you holding up?

CK: I'm holding up pretty well! I'm not wallowing in a lot of self-pity here. And I'm actually kind of surprised that I've been given a platform—a bit of platform. Not a whole platform, but a part of a platform to explain myself in some of these articles. Southern Poverty Law Center actually let me say a few things. And so did the *Jewish Daily Forward*.

I mean, it's all negative; I'm being painted as an evil artist. But people who have been following this controversy have been noticing that the treatment I'm getting is with kid gloves. I'm not really being excoriated as viciously as I could be.

GJ: Yeah, I've noticed that too. I mean they are actually bothering to contact you for quotes and then reproducing them fairly accurately, I would assume.

CK: They don't want a lot of quotes, of course. Because they don't want to examine how I arrived at my opinions.

I tell them I wish the article would be less about me and about my art, and more how it is that somebody like myself could end up with opinions that you claim I have. What's the process, you see? But then they don't want to follow the process, because then somebody else might get the idea that how I arrived at these opinions was through scholarship. That it isn't as bad as thinking that I want to gas six million Jews.

GJ: Yeah, you didn't wake up one morning with a blind, murderous hatred in your head and decide you want to research the history of the Holocaust hoping that it would come out differently, or something. I think that's interesting.

It strikes me that if a person is a really articulate, rational advocate for certain ideas, that the really smart people in the opposition camp don't want to give them a lot of publicity. I mean, the Anti-Defamation League and the Southern Poverty Law Center didn't really go to great lengths, for instance, to do anything to publicize and excoriate Wilmot Robertson. They let him be pretty much in peace. And I think that the reason why they did that is that they thought, "Well, this guy writes really classy books. He's a very reasonable person. Obviously highly intelligent." They didn't really want to draw a lot of attention to him. They generally want to draw attention to people who are crazy-sounding or buffoonish, and if they can't find somebody like that, they're always willing to create them themselves—as we've discovered with things like this Norwegian Defense League.

So I was a little surprised, frankly, that this article popped up, because it doesn't seem like a really smart move from a propaganda point of view to want to give you a spotlight or a platform to talk about these things. Because a lot of people might think, "Well, this guy doesn't seem crazy to me" and follow you down the rabbit hole.

CK: Yeah, they did say, though, after I got my two cents in, that I might be senile. Did you notice that? That I'm getting into the period of my life where senility might be setting in. [Laughs]

GJ: Yeah, that rich! That's really funny!

CK: So that's how they're explaining this thing; you know?

GJ: Their motto is *never forget,* and, obviously, you're starting to get forgetful. So maybe that explains it! [Both laugh]
Do you know Jen Graves personally at all? Have you come across her at a gallery or anything like that?

CK: Yeah, I met her at various art openings and events in Seattle to speak with her just briefly. And she interviewed me once for a radio program that she did, and we had a pretty nice back-and-forth. So I can't remember exactly why I was being interviewed, but I remembered that I enjoyed talking with her. And I don't follow her articles, really, in *The Stranger* very much, and I don't socialize with her regularly, but I was aware of her, and I had been interviewed for one of her podcasts.

GJ: Do you know of any personal reason why she would have it in for you? Do you have any speculations as to why she wrote this article?

CK: She was notified, anonymously, that I was a bigot, by, I believe, a community college art teacher out here. Because this art teacher messaged me on Facebook and said, "I'm very surprised that you haven't been outed by the Seattle art community for your bigotry and your Holocaust skepticism." She didn't phrase it "skepticism"—that's my phrase—but Holocaust denial. I wrote her back, this woman. I messaged her back. I said, "Well, if you think I should be outed, maybe you should be the one to do it." So I think I gave her the idea to write this letter to Jen Graves. Then I get an email from Jen Graves asking me point-blank: "Would you like to write about Holocaust revisionism for *The Stranger*," I think that was part of this letter that I got. And "Are you a Holocaust denier?" She said, "Somebody has written to me accusing you of this. Are you?" And, oh, ". . . are you? And would you like to say something for *The Stranger*." I don't think they were offering me column space, but "Would you like to make a comment about this accusation for *The Stranger*?" I guess she was going to be prepared to say something about it; in my defense, maybe. Because at that particular time, I don't think she had any animus towards me.

I told her: "Well, listen, unless you want to write about this in conjunction with some art that I'm exhibiting somewhere, I don't feel like I have to answer the question 'Am I a Holocaust denier?' because it's obvious that whoever put you up to this doesn't have my best interest at heart." This is a no-win question. So I'd rather not answer it unless you want some further explanation of some art I have on exhibit somewhere. Because this isn't about my art. This is about me and my politics. I didn't say that, but that's what I was thinking. I was thinking to myself, "Well, just stick to the art." Whether or not I'm a Holocaust denier has nothing to do with the art I might be exhibiting somewhere in Seattle that month.

So I didn't answer the question. And she wrote back and

said, "Fair enough." And then she came back four months later and she just announced that she was going to go ahead and write about this. And I learned from some of my associates and friends in the art community that she had been polling people, getting comments, harvesting opinions about me, and that this article was going to go through. And I could either say something about it to her or not, but she was going to expose me.

GJ: Right. The first time, I think, I was in touch with you was maybe 2004. And I'd heard about your artwork before that. It was in one of the Pop-Surrealist books that I had. And then I remember, in 2005, the *National Vanguard* site, mentioned that you had won the Holocaust Historiography Project for the most outrageous Nazi Atrocity Story. That was in 2005. And then in 2006, you mentioned revisionism as one of your non-art related interests in an interview—I believe it was on an Italian blog called *The Extra Finger*. So this is hardly a well-kept secret and you have hardly gone to great lengths to keep this a secret. And it's kind of interesting that seven years later, finally, somebody has put this together in the mainstream and wants to bring you down or do you harm, I guess.

CK: Yep. I definitely think that they want to do me harm. Because this is part of a ritual defamation. And part of the defamation is to separate me from my friends, family, and see if they can't impact my ability to make a living.

GJ: Right. Well, it's good that you're not employed by some company that could be quietly pressured behind the scenes to fire you. You are an independent person. Which doesn't mean that you're immune to that, it just means that they have to get in touch with a bunch of different galleries. But then you've got private collectors and people who con-

tact you directly, so it'd be very difficult for them to completely cut you off from a market.

CK: Completely! But listen, now that I've been smeared, I'm not going to be able to go for grants and fellowships, you see? Nonprofit art support organizations aren't going to want to give me money to travel and complete projects using either city, state, or federal government monies. Or private foundation monies. I'm too toxic now to be able to be awarded any grants or residencies. I'm on a blacklist, a college blacklist of events. Directors, they've got some kind of thing that they're circulating with my name on it that says it would be best not to have me included in college art gallery shows or to be invited onto a campus to lecture about my art. And that was part of my income stream for a while. I was being brought to ceramics departments in universities to talk to the graduate students. So I think that's over now.

GJ: Right. Well, I'm really sorry to hear that. On the other hand, this does give you a little bit more freedom, I suppose.
What use are you going to make out of this new situation? Are there ways that you plan to turn this to your advantage and to the advantage of the larger community.

CK: I don't really know how to turn this train-wreck around. And if somebody has an idea, by all means, pass it on! Because I'm sort of stymied here. I'm not going to waste a lot of time feeling sorry for myself; I'll just continue to make my art. I've noticed a spike in my friend requests on Facebook, so my notoriety is causing more people to want to be a Facebook friend, but that doesn't translate as extra income, really. And I guess I could use this little "window of notoriety" where the media is interested in me, to maybe get the word out about revisionism and White Nationalism.

GJ: Well, that would be a good thing!

Let me segue into talking about revisionism, in particular. First of all, you reject the term "Holocaust denial." That term brings to mind pictures of some Puritan witchfinder-general standing up and saying, "Do you deny the existence of God or the divinity of Christ?" It's an Inquisitor term. It's very loaded. And, for one thing, it's question-begging, because it presupposes there is this massive, incontrovertible fact, and you're guilty of the perversity of denying it.

CK: Well, listen. I've learned that most people—who have never even read a revisionist text let alone a bestseller on the Holocaust, like Goldhagen's *Hitler's Willing Executioners*—these people that are so upset about Holocaust deniers. They think that we are denying that there was a Holocaust. The whole thing. They say, "How could you deny the pictures of the corpses that were being bulldozed into the pits at Buchenwald?" Or, "How could you deny that my great-aunt has a tattoo? Where did she get that tattoo? How can you deny that so-and-so didn't go through a concentration camp?" They think that the whole thing—lock, stock, and barrel—is being dismissed as some kind of hoax or a lie.

GJ: Right. It's a strawman, in other words.

CK: It's a complete strawman. We don't deny that there was a Holocaust. We just deny some aspects of this received history—this series of events that they call the "Holocaust." So I have to spend time educating some of these people that have been contacting me or commenting. Listen, I don't want to spend a lot of time in the comments boxes below the articles wherever they've appeared. I'd be wasting too much time. But at my Facebook page when I've been attacked for denying the existence of concentration camps, for example, I've got to qualify what "denial" is.

It's an umbrella term that's been weaponized by the Holocaust industry to make everyone who has a doubt about the Holocaust be called a "denier" and then to look stupid. Just to look like we're crazy.

GJ: Yeah. Stupid, crazy, or evil. So you'd call yourself a "skeptic," then?

CK: Yeah, a "skeptic." I like that term.

GJ: And in terms of White Nationalism, and things like that. What term are you comfortable with describing yourself as?

CK: A "white advocate."

GJ: Okay. And how do you define that?

CK: Well, someone that is racially aware of their whiteness. And is proud of the achievements of European civilization.
That's essentially what I am—a European-American who is an advocate for preserving European-American traditions and proud of the accomplishments of European-Americans.

GJ: That's good. That's very good. And you are explicitly opposed to the use of terms like "white supremacism" and things like that?

CK: It's another weaponized media attack term. You know what I mean? Who, in their right mind, would want to have to reign supreme over the races? I mean, it's ridiculous that anybody wants to control all of them.

GJ: Right. A hundred years ago, various European powers controlled practically the whole globe, and there was definitely a supremacist element to that. The Russian Empire, and the British Empire, and the French Empire and things like that.

CK: Right. The colonial eras, right?

GJ: Right, and in America, of course, there was Jim Crow and things like that.

CK: In a multicultural society, all that I am asking is to be left alone to be white. [Laughs] Essentially. I don't want to reign supreme over the other races. Yeah, okay, that's about all I want to say. Leave me alone! I don't want to be made to feel guilty for things I didn't participate in or have any chance to participate in. The guilt of the father, or the guilt of the grandfather, being passed onto me. I mean, come on! I wasn't there for slavery. My family didn't own any slaves. We came years after the Civil War.

And this whole business about my people being the cause of all of this, whatever that you, whatever anybody else finds not good about Western civilization—I don't want to be burdened with the guilt for it! I wasn't around for it.

GJ: Yeah, and if they really believe in collective guilt, then shouldn't they also believe in collective pride?

CK: Yeah, but we're not allowed to take pride in anything because they're worried if we take too much pride in what we do then we're going to start up the gas chambers again!

GJ: Right! Right! The phrase we like to use at *Counter-Currents* is: "We take our own side in ethnic conflicts." If

there are groups that are pointing their finger at white people and claiming that we're the source of all evil in the world, you'd have to be a completely suicidal nitwit not to take your own side in those conflicts.

But a lot of liberal whites, they're falling over themselves to accuse themselves, and hate themselves, oftentimes over completely spurious things. And yet, even though they are willing to accept collective guilt for things that other white people have done, they're never willing to consider maybe feeling a little bit of collective pride for all the accomplishments of their kinsmen. And the danger of that, of course, is when you start comparing the tallies of things to feel bad about and things to feel proud of, there's quite a lot to feel proud of: the things that Europeans have done in the world.

CK: I think so too. And I don't understand this rush to dismantle Western civilization, to tell you the truth!

GJ: So what advice do you have for other people who are given this kind of treatment in the future? Do you have anything you would say to somebody who suddenly has an article published about them—"outing" them?

CK: [Pauses] No, I don't really have any advice for anybody else that might find themselves in my position. It could be a lot worse than it is. And it's nice that we have a First Amendment so that I'm not being charged with a "thought crime" and possibly tried and then jailed for it, you see? So I feel pretty lucky!

That's another thing I don't think that Americans realize about Holocaust skepticism—is that it's a jailable felony in 14 European countries, where skeptics are sitting in prison right now because of translating—one fellow, Günter Deckert, translated a Holocaust revisionist text from Italian into German. He's doing five months just for doing the

translating. He's doing five months in a prison with murderers, thieves, and all kinds of riff-raff, you see? And all he did—his crime was *translating*! The author of the book that he translated could be also charged with "defamation of the dead" or whatever it is they're using to put these revisionists in prison. So, Americans, apparently, don't realize the extent of the taboo, what's been done to prevent people from looking at the full spectrum of the history of the Holocaust. It's been legislated against in Europe to investigate it.

GJ: Right. Last summer, I published a piece at the *Occidental Observer* called "Dealing with the Holocaust" where I argued that, from a White Nationalist point of view, revisionism didn't really have a great deal of political utility.[2]

CK: Well, it's a stumbling block, and I understand your position. And that's what got me into trouble, because when they wanted to find quotes about my White Nationalism, they went over to the white network where your essay was under discussion on Carolyn Yeager's program and Hadding Scott, Carolyn, and I were debating about your premise. So they were pulling quotes from that debate to print in *The Stranger* to prove that I was a White Nationalist. As a Holocaust skeptic that's spent quite a lot of time looking into the Romanian end of the Holocaust story, I can't really give it up, because I'm not finished with my research. But I understand why you would think that getting stuck on the Holocaust might prevent White Nationalism from being accepted more readily by non-White Nationalists.

GJ: Well, my position is that I think that all historical

[2] Reprinted in Greg Johnson, *New Right vs. Old Right* (San Francisco: Counter-Currents, 2013).

narratives are subject to revision, because as time progresses, you become aware of things like lies and propaganda that have been accepted as fact. You become aware of questionable assumptions that people brought to history in the past that you might want to question, and then you revise their narratives in light of that. And also, new information comes to light, and therefore all history has to be revised to bring it in line with facts, as Harry Elmer Barnes described revisionism. And then, beyond that, I think that it's an absolute scandal that the First Amendment does not apply to this and that there are people being jailed for engaging in skeptical, critical, historical inquiry.

CK: Well, not in America, where we have a First Amendment; in Europe where they don't have a First Amendment. That's the difference between our freedom of inquiry and freedom of speech and their lack of both.

GJ: Right, but unfortunately, our government has been all too willing to hand over people like Ernst Zündel . . .

CK: Oh! They're complicit. Yes, they are! They're complicit in having these people deported and punished and pilloried. And hate speech laws about Holocaust revisionist speech—they're on the books! I mean, they're waiting to be able to get them on the books here that we can't revise the history of the Holocaust in America either.

GJ: And that I am totally opposed to. Even though personally I'm not into revisionism, and I don't think it's a necessary part of White Nationalism, and it's not part of my particular take on it. But at the same time, I think everyone has to stand up for the freedom of speech of revisionists and defend, in principle, the necessity of historical revision in every case.

I also think it's a grotesque, absurd situation that the

United States government actually has made entry into NATO contingent upon having laws on the books that penalize freedom of speech and inquiry. Basically, if a country like Romania wanted to adopt the Bill of Rights of the United States, the United States would oppose them getting aid or becoming a member of NATO. So our government actually is actively opposed to any country that would want to adopt the American First Amendment, because they want to push ahead the criminalization of this particular form of historical inquiry.

CK: Exactly! And that happened to Romania when it entered the NATO-sphere and then again when it was accepted into the EU. And I think one of the rules for EU membership is you have to outlaw "hate speech" as it applies to the Holocaust history. And then there's also an imposition of Holocaust studies, the curriculum of the Holocaust imposed on the schools. So they can get it taught beginning with primary school through college. They have a whole curriculum ready to be used in the school systems of the EU countries. Did you know that?

GJ: Yeah, yeah! It is shocking and very, very interesting, the priorities of the American government. Our government talks about exporting freedom and democracy around the world whenever it, say, wants to get in another war in the Middle East, rub out another enemy of Israel in the Near East; they're always talking about exporting freedom and democracy. But when it comes right down to brass tacks, in Europe, they are actively opposed to any country having the American Bill of Rights. Especially the First Amendment, and I think that is an eloquent testimony to the real priorities. Just like it's an eloquent testimony to the priorities of our education system and our regime that every American thinks he knows how many Jews died during World War II, but practically none of them have any

idea how many Americans died during World War II.
CK: I didn't until I looked it up. I had no idea.

GJ: I had no idea either. And I had a Ph.D. and I still had no idea what that number was until I actually went out and looked it up. And the other thing, of course, you point out is that it's really extraordinary that they built a Holocaust museum before they built a memorial to the soldiers and other people who died in the Second World War.

CK: Yeah, the memorial that they built to the soldiers in World War II is only, I think, only about five years old. It's very recent. And the Holocaust Museum went up right there in the heart of everything—next to the Lincoln Memorial and the Washington Monument.
Let me just reiterate: These people that died in the Holocaust didn't live in America, they didn't die in America, and they didn't fight for America. So I don't understand why, on Pennsylvania Avenue, they have to have a museum—this "museum of horrors," by the way—planted with all the other monuments to the greatness of the American way of life and American heroes.

GJ: Irmin Vinson talks about this in his Holocaust commemoration essay which we republished at *Counter-Currents*, and his book, *Some Thoughts About Hitler*, which we also published. He talks about the reason why Holocaust education and Holocaust memorials and museums are all over America . . .

CK: In every state in the Union!

GJ: In every state. It's not to thank America for its role in fighting Nazism in World War II and for the sacrifices they made. But rather it's premised on the assumption that Americans are a danger and that we need to be constantly

propagandized about this lest we get the same idea.

CK: Yeah, that we catch this lethal anti-Semitic virus, right, that would lead to another wholesale, industrial genocide of the Jews.

And plus, these places are set up to instill the guilt that we didn't do enough for the Jews of Europe. That somehow, the sacrifices that we made to liberate Europe, wasn't enough, you see? For the Jews, we could have done so much more. And that's constantly being reiterated in the media. I mean I just read another review in, I think it was the *New York Review of Books*, that another couple of Jewish intellectuals decided that maybe Franklin Delano Roosevelt wasn't so bad when he turned that ship back that was supposed to be coming here with the refugees.

Yeah, this guilt trip for Americans for not doing enough during World War II for European Jewry really chaps my hide! [Laughs]

GJ: So, Charlie, we're running out of time, really, but I want to ask you one more question: Has there been any good coverage in the mainstream media about this whole affair?

CK: No! There's been none. The only defense anybody has mounted for me has been your two essays.[3] And Adam Parfrey at his Feral House blog wrote a little piece that said that he supported me and my right to have these controversial and heretical opinions. But other than that, nobody has actually sat down and . . . I don't know, deconstructed like you did Jen Graves' article to point out all the agitprop behind her outrage.

[3] Greg Johnson, "The Persecution of Charles Krafft," *Counter-Currents*, February 14, 2013, and "Freude durch Krafft," *Counter-Currents*, February 27, 2013.

GJ: There was a piece in the *Toronto Globe & Mail* that I thought was . . . it wasn't exactly laudatory.[4] But I thought was at least intelligent. It provided some context.

CK: It did. It provided an artistic and cultural context for the use of Nazi iconography in contemporary art. He mentioned that Polish person and then an Israeli, that I wasn't aware of, who were both sort of playing with Nazi symbols. And I thought that was nice; at the end of the article he says Krafft's work remains . . . didn't he say "weirdly powerful"?

GJ: Yeah, "strangely powerful."

CK: "Strangely powerful," even though he's just been outed as a—what they're saying is that I'm a Nazi, right?

GJ: Right. They're saying you're Nazi. Well, maybe what will happen is you'll just be like Ezra Pound, or Heidegger, or some of these other figures. That it will sort of rattle around in the background, but people will still be looking at your work, taking it seriously, and displaying it. I hope that that's what happens. I really do.

CK: Well, I think that will happen. But at the same time, if I don't generate more conversation about the things we've just discussed in the mainstream media then this all has been kind of for naught; I mean, my martyrdom is going to have been for naught! I'd like to see more people outside of *Counter-Currents* . . . we're way off in the fringe of media, you know? I don't understand why they can't talk about it, let's say, at *The Nation* or some other place that

[4] Russell Smith, "Nazi-Themed Artwork: Monstrous Art or Art about a Monster?," *Toronto Globe & Mail*, February 27, 2013.

has a wider audience because these are issues that I think should be addressed by thinking people.

GJ: Well, why don't you approach, say, Alexander Cockburn, or somebody like that—people at, say, *CounterPunch*? These people do sometimes think outside the box.

CK: They do. I suppose I could. I could do that. Alexander Cockburn just died, you know? Who's left over there?

GJ: Oh, well, I didn't know that. I'm out of touch. I hadn't tuned into *CounterPunch* for a while. That's sad. I didn't know that.

CK: Yeah, unfortunately, he's dead. He died about six months ago.

GJ: Okay, well, I really haven't been tuned in over at *CounterPunch* for a long time, then!

CK: Who's that libertarian that we like—Anti-War.com?

GJ: Oh, Justin Raimondo.

CK: Yeah, Justin Raimondo! He's about as good as Alexander Cockburn used to be.

GJ: Yeah, it would interesting. I think he would run screaming from the idea of any kind of historical revisionism, even though he knows, that as far as the neocons are concerned, it's always Munich 1938, and we're always refighting the Second World War. I really do think, in general, the Second World War has to be treated under a magnifying glass and our understanding of it has to be reevaluated. Because every new war that's being sold is being sold on the model of a particular whitewashed narrative of the

Second World War. And until we really question that narrative of the Second World War, we're not going to ever be able to avoid the people who are pumping for a Third and a Fourth world war. And that's really the great political problem of the globe, I think. And so I do think revisionism, in a broad sense, is absolutely necessary if we're going to save the world from nuclear holocaust, frankly.

So, Charlie. Is there any last thing you want to say?

CK: Your comment about revisionism being good for peace, future peace. Let me recommend Herbert Hoover's secret war diaries that were just published.[5] There's about 970 pages of really solid World War II revisionism there that for people that are interested in World War II, I recommend that book.

GJ: Well, great! Thank you very, very much. I really have enjoyed having you on. And we really appreciate what you've done. We appreciate you being courageous and standing your ground and stating your views publicly for all these years. And I hope the bastards don't get you down!

CK: Well, I don't think that they're going to get me down. And if they do, I'll be running to you for help! [Laughs]

GJ: Well, okay! We'll be in touch one way or another.

CK: Yeah! Okay, thanks a lot!

GJ: Thank you! Bye.

[5] Herbert Hoover, *Freedom Betrayed: Herbert Hoover's Secret History of the Second World War and Its Aftermath*, ed. George H. Nash (Stanford, Cal.: Hoover Institution Press, 2011).

GRACE UNDER PRESSURE

October 13, 2013

Charles Krafft spoke again at the *Counter-Currents* Retreat in Santa Cruz on Columbus Day weekend, October 12–13, 2013. On the morning of October 13, he took part in a session called "Grace Under Pressure: Dealing with Attacks," based upon his "outing" as a thought criminal earlier that year. I would like to thank Hyacinth Bouquet for this transcript.

Greg Johnson: All right, let's begin our final session. This session is called "Grace Under Pressure." It's a very practical session. It's a chance for people who have experience to pass on their experience to the rest of us.

One of the things that we all have to deal with is the potential for people pointing at us and saying, "Fascist!" "Racist monster!" How do you deal with that? So the title is "Grace Under Pressure: Standing Up to Public Attacks."

I'd like to invite Charles Krafft to come up. Charles Krafft has spoken at our last event, but just to give you a little introduction, if you haven't already met him, or seen his work: Charles is a porcelain artist and a painter, and he lives in Seattle.

Early this year, the forces of political correctness finally caught up with him. For the better part of a decade, I've known Charles Krafft's work. I've also known that he's a "thought criminal." He's given interviews, written blog posts, and won prizes for writing revisionist essays. And yet it took about eight years for the art world to finally catch up with him, put two and two together, and say, "Maybe this guy isn't being ironic. Maybe this guy is a thought criminal."

The *Stranger*, which is one of those alternative weekly papers, material for which is provided by journalist/barista/waiter types . . .

Charles Krafft: Plus, transgendered call-girls.

GJ: Okay! Those too. Basically, *The Stranger* is cultural Marxism in the first half of each issue and then ads for call-girls and massages in the last part. Cultural Marxism and pornography and prostitution. That's their business plan. The typical alternative-weekly business plan.

Anyway, they went after Charles.[1] Salon.com took it up. It became a national thing; and all of his friends were saying, "Oh no! It's happening to Charlie." And Charles Krafft stood up to them. He didn't back down; he didn't apologize.

It was really inspiring. I wrote a whole piece about this.[2] I even went and waded in on discussion boards and mixed it up. It was a lot of fun. But Charles didn't back down. So I just want everyone to applaud him right now.

I've said too much about this already. Why don't we begin with Charlie Krafft. Charlie, do you want to tell us about not backing down?

CK: The whole thing of my "outing," we'll call it, started on Facebook. *The Stranger* article was a result of an anonymous letter from a psychology teacher at a small college in Washington state who had written me on Facebook in my personal message box, asking why the community hadn't exposed me as a bigot.

[1] Jen Graves, "Charles Krafft Is a White Nationalist Who Believes the Holocaust Is a Deliberately Exaggerated Myth," *The Stranger*, February 13, 2013.

[2] Greg Johnson, "The Persecution of Charles Krafft," *Counter-Currents*, February 14, 2013.

The reason why this psychology professor thought I was a bigot is because she mistook the sock-puppet of one of my commenters on my Facebook page as me. The sock-puppet was throwing around a lot of rather vile, gutter, anti-Semitic slang, and also racial slurs. Ethnic and racial slurs of the most extreme kind. Because this person—I know who the sock-puppet was—felt that this was some kind of a way to, I guess, promote the cause.

I wrote back to the psychology professor. I said, "Number one, that isn't me. You might think it's me, but it isn't. It's somebody else. Number two, I don't want to censor anybody on my Facebook page. I don't care if they are using the k-word, or the n-word. I just don't want to be monitoring the comments." Because I would post things that intrigued me, basically revisionist videos and things like this, and then there would be strings of comments from people. And this one particular commenter named "Elsa," who is actually a male, would get on there and rip everybody a new asshole and use really vile language to do it.

My White Nationalist friends, of whom I have maybe a dozen in Seattle, cautioned me about letting this go on. They said, "Listen, this guy is going to really get you in trouble if you don't block him/her." Well, I didn't do it, and I got in trouble. And, I had no idea that the trouble I got into was going to be international. I thought, what's going to happen is it will be a local story for this little newspaper that Greg described.

Our community is insular, and I didn't think it would go beyond that. I have enough friends up there, and had been living there and exhibiting long enough, so that I have a certain degree of respect built up over the course of a lifetime. I'm in the museum, and I used to be a journalist at an art paper, so I'm also a bit of a critic. I'm a curator. I put together shows in Seattle that were very popular with people. And I'm an eccentric. I'm sort of like a character on the art scene. Kids look up to me because

I've been at it all my life, and they're starting out. They want to know how do you survive without a day job. That's the big thing.

The psychology professor wrote the anonymous note to the art critic. The art critic wrote to me and said, "You've been accused of being a Holocaust denier. Would you like to say something about that?" I wrote back to the critic and said, "Well this is a no-win situation. I don't want to say anything about it." That was it.

She wrote back, and I had written a paper about the Holocaust in Romania, which was kind of academic. I said, "This is the only thing I've ever written about the Holocaust. Here it is. You read it. You tell me. If you think I'm a Holocaust denier, fine. I don't want to comment on this." She wrote me back and said, "Well, okay; fine. Fair enough." That was the quote. "Fair enough." If you don't want to comment, no comment, that's fine. It won't be pursued." Which I thought was okay, and I let it go at that.

Eight months later, I got a letter back from the critic. I'm on my way to Asia. I'm in Asia, actually. I'm in India. She's saying, "I've been tracking you on the internet. You've got your name at these various White Nationalist"—they don't use the word, "White Nationalist"; they call it white supremacism—"at white supremacist websites. You've got your name there. You're all over the Holocaust revisionist blogs with your comments. I have some questions I want you to answer. You can either answer these questions, or you can refuse to answer them again, but whatever you do, I'm going to write about you. And, essentially, you're going to be outed by me."

There were seven questions she asked, which I answered. I'm a fairly honest person, and I don't like to play these Jewish games, where you're always strategizing with your enemy, trying to outsmart them. I'm just kind of a dumb ox. I know what I think the truth is. And rather than protect it with a bunch of weasel-words, or corkscrew

logic, or *pilpul*, as they call it, I'm just going to take my medicine. Like I used to do with my dad, when he was mad at me. "It'll be over in a while," I always tell myself.

She went ahead and wrote this article. That I'm a White Nationalist—God bless her, she didn't say "supremacist"—and a Holocaust denier. Well, of course that's the worst thing in the world to be in the art sphere—which is totally cultural Marxist. There are very few people like me, and at this little kind of minor level of celebrityhood that I achieved, in the world of the crafts. I thought, like I said, it would be over, and I can get on with my life.

Well, Christ, the *Huffington Post* picked it up immediately, and then somebody else at the *Huffington Post* had to chime in. So, I got two *Huffington Post* articles excoriating me. Once it was in the *Huffington Post*, it went to *The Guardian* in England. They had a poll there: Should my art be taken out of museums? You vote "yes," or you vote "no." *Vice Magazine*, which is supposed to be so edgy, called me up and interviewed me. And then, after I was interviewed, completely smeared me, misquoted me, made me look like a crackpot, and generally left me in the dust as a "hateful" person. The thing is, it's "hate." They want to make you into a "hater."

Then the *New Yorker* called. And, it's this Jewish young reporter, who writes about culture and the arts for their blog. It's not the print edition of the *New Yorker*; it's their blog. She wanted to interview me, and I thought, "Okay, fine." I gave her two hours of talking about what I do and my career. That's fine. The *New Yorker* piece is kind of okay, because they asked the question: Should we censor this man? Should the museums that have bought his works get rid of them now? And can artists who are like me—"haters"—should they be allowed to participate in the cultural sphere?

When you go to the comments at these places, it's amazing to see how much and how many people think

that this is extremely dangerous to have an artist with ideas like mine. They want to censor you. And then, not only do they want that to happen to you, but at the same time, they don't even know you, but they want to kick you when you're down. They just make up things about you. It's amazing. People came out of the woodwork and started telling stories about me that had never happened. They claimed that I'd been mean to homosexuals. I had nothing to do with this issue.

They put words in my mouth in some of these articles. There were 72 of them, by the way, at last count. Big mainstream places and small blogs. I got defended by Greg, and I got defended by some other people. But the defense was nowhere near as copious as this excoriation, this public *auto-da-fé* I had to go through.

The result has been, I was elevated from a regional and a kind of small-time national fame. My fame went way up into the international sphere. I've never been more famous than I am now as a result of this. I was really a small-time guy. But they made me look like I'm the king of American ceramics. And look at him: he's a Nazi. And we're going to take him down!

Now, as a result of the attention I got, my celebrity rating spiked way up. Business-wise, I attracted a new audience of people that are Jew-wise, people that are leaning towards White Nationalism, people that are on the Right, who hadn't heard of me before. I guess they think that it would be a good idea to support me, because they can consider what I'm doing now a bit of a crusade. And a losing battle. So there's that.

My audience doesn't have a lot of money and never did. I sell to young people. I've kept my prices down so that if they have any discretionary income that they want to spend on art, they can afford my pieces. It's not like you spend a lot of money on my work: a couple of hundred bucks, you can have something by me. The kids used to

love it, because it's edgy. And they like guns, and I make guns. I comment on their culture, because I'm kind of in tune with it. I'm respected by this younger generation of creative people that are sharing their interests and their heroes with me.

So I haven't been left behind because I'm as old as I am. I've sort of been brought into a new generation of art makers, as a senior, as a respected senior with this kind of edginess. That's nice.

Other notes that I took for myself about explaining what goes on when you get smeared like this is the worst thing that happens to you, the immediate family. Suddenly you're in the newspaper. I was on the cover of the *Seattle Times* as a Holocaust denier. The Sunday paper. There I am, in my studio, with a bunch of Hitler teapots behind me. With the editorializing that went on, it's just, "This guy doesn't believe in the Holocaust."

Of course, I believe in the Holocaust. But with this kind of attention, nobody's going to wait for you to split hairs. The charge has to be lobbed at you, and it sticks the way it is. "Denier." When they read "denier," that means you deny the whole Holocaust. It makes you look silly. Because I don't deny the Holocaust. I have some skepticism about some of the received history of the Holocaust, but nobody wants to hear you say that. Especially the people who do the reporting about it—reporting about you being a Holocaust denier, because they need a hook to hang their story on. The hook is the scandalous nature of your thought crime, and then, there it goes.

Now I'm stuck with the picture of me on the cover of the city paper, and as Thanksgiving is coming, I usually spend it with my brother, his wife, and my two nieces. Well, one of the nieces is engaged to a Jewish person, and the Jewish family of the niece is coming for Thanksgiving, and so I'm not invited that year. I don't have a place at the Thanksgiving dinner table, because my brother and his

wife are worried that something untoward is going to come out of my mouth when the issue of me being on the front page of the paper comes up.

It hurts. That's what I want you to know. When your family starts to think about leaving you out of family situations, because of this political stuff that you're into, it's painful. I can't tell you it didn't hurt my feelings, not to be able to go to Thanksgiving every year. I'm 65. If it wasn't with my mom and dad, it's with the rest of the family that's alive. We celebrate it together. But they were worried I was going to start bringing out the Holocaust statistics in front of these middle-class Jews from this bedroom community that my niece is marrying into.

That's kind of a metaphor for the rest of the trouble I've had, with friends turning against me. Letters I got from people that I had known for the course of my life that wanted to put in writing how disgusted they were with my politics and my attitude. They sign off on this stuff. You get it in the mail. You open it up, and it's somebody that you haven't seen for a few years. Somebody you thought was your friend, and they're divorcing themselves from you. They don't want to have anything to do with you anymore.

I tried to answer some of these letters. There weren't a lot of them; there were about three. I just thought, I'm not . . . When you're reading comments about yourself in some of these blogs, you want to get in there and answer. I told myself, "Stay out of the fray. Don't waste your time trying to educate anybody. Allow yourself to be interviewed by anyone that is coming along that wants to interview you."

NPR called me up, by the way. Studio 1A. That went out around the nation at about four o'clock, commuter traffic everywhere, where all the NPR listeners are tuned in to those stations in their various cities. Nothing but cultural Marxism comes out of NPR. NPR, I just call it "Jew-PR." I

know it's kind of crass to say this, but top to bottom, the executives to the announcers, and to all the people in the field that are reporting from different parts of the world, they're all Jewish. And it's a Jewish agenda, and this Holocaust thing really upset this one guy. He suggested on his program that I needed a psychiatrist.

I just said "yes" to everybody. I didn't care who it was. If you're on the Right, if you're Harold Covington of the Northwest Front, he wants to get an interview from me? Fine. Harold, I'll come up and talk on your Nazi radio station. I don't care. Fine, NPR. You want to hear what I think? I'll be on your radio station. I did this for two months.

Finally, the local Jewish newspaper in my city, one of the reporters called me, and she wanted to get a scoop. And by that time, I was really tired of talking about this issue. I said, "Before I deign to give you a scoop, all you people have done is just get me to talk so that you can hang me. You want me to create the rope that you're going to use to hang me!" I said, "I will give you an interview, but before I give you the interview, would you please watch these two videos?" And this woman would refuse to watch the videos. So I didn't give her an interview.

It's a class. It's the chattering class. They have some sort of social status, and they have some sort of expertise, I guess, and social dialogue. And they think that you're going to have to drop everything you're doing so that they can have their story, which is always going to be negative, unless it's a little Counter-Currents Radio show, like Greg runs. I just told her, essentially, "Fuck you. I'm not going to sit down and do this for anybody else, because I know that you're going to hang me, and, furthermore, you didn't bother to even go to these URLs. I asked you to do your homework. I mean, come on! Do some homework before you lob these charges at me." And she wouldn't do it. So I

wouldn't give her the interview, and that's the way I'm going to be with everybody else that comes down the pike now.

The story's over, by the way. These things only last three months, max. Then they get on to somebody else. You could go back to your life, but it's changed forever, because you've got the family; you've got the girlfriend; you've got the wife. And you've got the people in your neighborhood that have been notified that you're some sort of *persona non grata*. You're a moral leper, and you've got to deal with this.

You go into the supermarket . . . I went to some place to get a dinner. The damned waiter wanted to ask me about what I thought. And he's an antifa! You know, he's out on the barricades with these balaclava'd Marxist thugs, busting up David Irving lectures, for God's sake. He wants to get in there and needle me while I'm having my dinner. That's what you can expect if you get smeared by the media.

You can stand up to it, yes. You turn a point in your life that you cannot go back. I remember reading Kevin MacDonald's *The Culture of Critique*. I turned a corner. There's no possible way I can undo what I've learned from that book. Like I said, my dad used to beat me. Not harshly, but I deserved it. I would tell myself, "The beating will be over, soon! And then everything will be okay. Dad and I can go to the ballgame again and go fishing. I just have to get through this one."

So that's my attitude. When you're thinking thoughts like we think, and if you're being public about it, you're going to attract attention. Somebody's going to get a burr in their bonnet, get a bee in their bonnet, and go after you. Hopefully, it's not going to be a violent attack, because that does happen, if you're out on the barricades.

With intellectuals like us, we can just expect these

smears and this hubris from these people that are supposed to be educated. It's beyond belief, these people. College-educated citizens, good citizens, they have been brainwashed to the point where this is a religion with them. They actually think they've lived through the Holocaust; they've seen so many damn Holocaust TV shows. And they'll bring it up: "What about . . . ?" And I'll say, "Excuse me, but that was a movie starring Kirk Douglas."

The most hurtful thing about having your reputation attacked and destroyed—it's not really destroyed, but you have to put up with this—is this family thing. I was talking with Kevin MacDonald last night about how painful it is. I think if it happens to any of you here in this room, and you are worried about it, just call me up, and I'll help you through it.

A Proust Questionnaire

2013

If I were . . .
A virtue? **Honesty**.
A fault? **Parsimony**.
A quality? **Kindness**.
A male quality? **Courage**.
A female quality? **Generosity**.
A quality I appreciate in my friends? **Humor**.
A favorite occupation? **Bookseller**.
A dream of happiness? **Travel**.
A great misfortune? **Blindness**.
A place to live? **Montenegro**.
A flower? **Chrysanthemum**.
A bird? **Peregrine Falcon**.
A prose author (or several)? **Douglas L. Reed**.
A poet (or several)? **Philip Larkin**.
A composer (or several)? **Arvo Pärt**.
A painter (or several)? **Bernard Buffet**.
A comic book artist (or several)? **Robert Crumb**.
A painting (or several)? ***Each Time You Carry Me This Way*, Morris Graves**.
A music album? ***Ceremonials*, Florence and the Machine**.
A comic book? ***Trucker Fags in Denial*, Jim Goad with Jim Blanchard**.
A memorable concert? **The Beatles, Seattle, 1964**.
An unforgettable movie? ***Gaza Strip* (James Longley)**.
A memorable exhibition? **"Kustom Kulture," CoCA, Seattle, 2004**.
A fictional hero? **Philip Marlowe from detective stories by Raymond Chandler**.

A fictional heroine? **Annie from the movie *Tugboat Annie*.**
A real-life hero? **Charles Péguy.**
A real-life heroine? **Isabelle Eberhardt.**
A dish? **Panang curry.**
A drink? **Ginger beer.**
An aversion? **Boring people.**
A forgivable mistake? **Bad posture.**
A despicable historical figure? **Bernard-Henri Lévy.**
A despicable historical fact? **Disneyland.**
A gift of nature? **Comeliness.**
A way of living? **Simply.**
A way of dying? **In your sleep.**
My current state of mind? **Disappointment.**
A motto? **"God is a comedian playing to an audience too afraid to laugh,"** Voltaire.

Counter-Currents Radio Interview

January 17, 2014

In his last interview Charles Krafft gave to Counter-Currents Radio, he looked back on his outing and the controversy it created, and he talked about the personal and professional consequences thus far. Charlie also proposes an alternative arts anthology. We had further discussion of this project. I wanted to call it *Krafft's Cabinet of Curios*. It did not come to pass, however, largely because *Mjolnir Magazine* debuted later that year and seemed to be filling the role. I would like to thank Hyacinth Bouquet for this transcript.

Greg Johnson: I'm Greg Johnson. Welcome to Counter-Currents Radio. Our guest today is artist Charles Krafft. Charlie, welcome to the show!

Charles Krafft: Thank you. Good to be talking to you again, Greg.

GJ: Well, it's good to be talking to you. You have had a really eventful 2013. Back at the beginning of the year, you were outed by a local alternative paper, *The Stranger*, in Seattle, as not just a revered porcelain artist who's been exhibited all over the world, but also as Holocaust "denier" and as a "racist" and a "White Nationalist." And that led to a firestorm in the media.

I'd like to talk about that today. Just recap it a little bit and talk about what's happened since then. Because a lot of

our listeners probably worry that someday they might be outed as a White Nationalist, for instance, and they worry about the consequences for them.

You have provided a really good example of somebody who was singled out in the media for attack. You stood up for yourself, and I'd like to find out how it's all played out in nearly the one year that has passed since then.

CK: Where do you want to begin?

GJ: Well, let's begin with the attack. What happened? Just recap it a bit.

CK: The story, in a nutshell, is that I had a kind of a stalker on my Facebook page, who was using pretty crude language, who people thought was a sock-puppet of mine. One of the persons that thought I had a sock-puppet with a foul mouth was a psychology teacher at a local college, who messaged me on Facebook. Her message was that she was surprised I hadn't been outed as a "bigot" by the local art community. She mentioned this poster on my Facebook page, and I told her that it was not me and that, furthermore, I was not going to censor the poster because I didn't like censorship—even if the poster was kind of using crude language. And I said, "I really don't like censorship, at all."

I also suggested that if she felt I should be outed, maybe she should be the one to do the outing. So, apparently, she did write a letter to the local art critic and outed me to the critic, who wrote to me and asked me what I thought about the Holocaust. I wrote that critic back and said, "Well, gee, I'm between a rock and a hard place. I've written one essay about the Holocaust, which I can send to you, if you'd like to look it over." Which I did.

I told the critic that I didn't want to be interviewed at that particular time about this. She was angling for some kind of a story, obviously. So, she wrote me back and said,

"Fair enough, if you don't want to pursue it."

About eight months later I got an email from her, and she said, "Whether or not you like it or not, I have to write about you. I have some questions I'd like to ask you. You can answer them, or you can not answer them. Whether or not you do answer, or not answer, it's not going to make any difference to me. I'm working on a story, and it's coming out soon."

I said, "Okay, fine. Send me the questions you want answered." So, I got a series of questions, which I answered. And then this story came out while I was in India, attending the Kumbha Mela, which is a big Hindu religious festival that happens once every 12 years in Allahabad. I thought, from India, that this story would be a small, kind of gossipy, storm in a local teacup in Seattle, where I've lived all my life, and I know all the people here that are involved in the arts. Not all of them, but quite a number of them. I thought, well, you know, this will be interesting.

I knew about *The Stranger*. I knew a little bit about the way they work, and I expected the worst, and I did get it! But that story went viral. It got picked up all over the world. And as a result of it going out and getting seen and picked up, I started getting requests from the mainstream media for interviews and comments. I said "yes" to everybody that asked me for an interview, and I must have done about five or six of them.

Finally, I got a letter from an editor of the local Seattle Jewish newsletter here. She wanted to interview me. I drew the line. I finally said, "I'm just going to be giving you more rope to hang me, and nothing good has come of most of the interviews I've given. I'm going silent now."

For a while there, I was an open book and saying "yes" to everybody. And then I finally just got tired of being interviewed, and so I quit doing it.

GJ: So, would you advise people who are in a similar situation simply not to give interviews at all?

CK: Well, I would advise them that they can give an interview, but if it's with a mainstream media outlet, there's no way that they're going to be able to put themselves over well. The cards are stacked against you going in. So you might as well. If you say "yes" to it—like NPR for instance—the way it's ultimately edited and presented will be probably a negative for you, if you're a White Nationalist or a skeptic about the received history of the Holocaust.

GJ: I remember the Kurt Andersen interview with you, and there was stuff in there that seemed obviously taken out of context. One of the things that I always recommend to people who give audio interviews, or video interviews, is to let the interviewer know that you're making your own reference copy of the interview, either audio or video.

I think that's one of the ways we can try and keep these people honest. But if they just have the only copy of the tape, they will cut it up and shuffle it around any way they want. And, yeah, their tendency is to put things in the most negative possible light.

CK: Yes, and they do a lot with that bumper music that they use! That Kurt Andersen interview was 30 minutes of talk back and forth with him, and I think it only ended up as seven minutes on his program. Seven to ten minutes. And he made me look like I was insane. I walked right into a trap that he set for me. I re-listened to it recently, and I thought I did okay, but at the end, he had the upper hand.

GJ: Yeah, yeah, you'd have to be a fool not to have the upper hand if you're the one who's holding all the cards and gets to edit the thing.

CK: Yeah.

GJ: So, that's the trouble with the mainstream media. They have all the cards. You give them the raw data. They fashion it into a rope to hang you with.

CK: Right.

GJ: We ran three articles about this at *Counter-Currents*.[1] Do you have an estimate of how many articles ended up being published about this controversy?

CK: Well, I have a friend who is an artist that was following the controversy, and he claims that he counted 71 places where this story, and permutations of the story, appeared on the internet. In print, the only things that came out were the *Stranger* article, hard copy. And I got, believe it or not, the front page of the local Saturday edition of the Sunday paper here. Then when the Sunday edition came out, I was in the lifestyle section on the front page. Because the Sunday paper comes out a day early here, and they have two. One for Saturday and one for Sunday. It's kind of an early Sunday edition and a late Sunday edition. And I was on the front page of the early Sunday edition.

So, just in print, only two places where it appeared. But a lot of blogs and websites picked up Jen Graves' story and just repeated it, word-for-word. So, if indeed there were 71 instances where my name and this issue appeared, on a blog or on a website, I would say two-thirds of that were just repetitions of the original *Stranger* story.

GJ: You also made the *Huffington Post* year-end round-

[1] In addition to my two pieces, already cited, see F. C. Stoughton's "An Open Letter to Kurt Anderson on Charles Krafft," *Counter-Currents*, April 9, 2013.

up. Tell us a bit about that.

CK: Well, the *Huffington Post* really made Jen Graves kind of famous, because they reprinted her *Stranger* story, and then two of their writers decided to comment on the story that she had written for *The Stranger*. So, I got actually three *Huffington Post* articles at the time. And then right before Christmas, they did a year-end roundup of the 12 biggest art fails of 2013, and I was number six on their list of the art fails. I guess they were being kind of cheeky. That was the point of listing these art fails.

GJ: Snarky.

CK: Yes, snarky.

GJ: Yes. So, what company were you in amongst these art fails? There were some pretty well-known artists and dealers who were mentioned there. It's kind of not bad publicity, in a sense, when you look at the people that you were in the company of.

CK: The one I remember most was the Bolshoi Ballet.

GJ: Exactly!

CK: Apparently, they put on some performance that everybody hated. But, anyway, there I am, with the Bolshoi Ballet. I can't remember the other people I was in the company of.

GJ: One huge Armenian-American art dealer, I forget his name, that was mentioned in there because one of his exhibits was not PC enough, or something like that. I thought, "Wow! You're in august company. You have all of

these people who have fallen afoul of the politically correct."

CK: Was it Tony Shafrazi?

GJ: You know, I don't know. I can't remember the name.[2] But anyway, I didn't really think it amounted to bad publicity in the end.

CK: Oh, I was absolutely thrilled to be remembered and then stuck in this august company, you know?

GJ: Exactly. So, tell us what happened to your exhibitions and speaking engagements and things like this, after the story started circulating.

CK: Well the speaking engagements on college campuses had sort of dropped off. At one particular point, a few years ago, I was getting invitations to give slide lectures to graduate students in the art departments of various art schools and universities around the country. That was a part of my annual income. I'd get an honorarium and probably a dinner out of the deal with the head of the department. And then I'd give my lecture. Then I'd visit the graduate students and do these personal one-on-one conversations with them about their work and what they might expect once they get done with school.

I learned from a kid in Ann Arbor, Michigan, who had wanted me to come to his college to talk, that I was on a list of proscribed intellectuals that were to be avoided by college department heads who were looking for speakers and visitors. I can't remember the acronym of the name of this organization, but there is apparently a group of academics who advise other academics on who is "good" and who is

[2] Larry Gagosian

"bad" for college speaking engagements. I'm now on some sort of a blacklist, I guess. He told me that his department head had brought him a sheaf of printouts about me that had been provided by this academic organization when they did a search on me.

So, I can't say that anything was canceled, because I hadn't had any invitations last year to visit colleges. But I did learn about being put on this list.

And what was the other half of that question?

GJ: What happened to your exhibitions?

CK: Oh, yeah. Well, I was in a show in Paris. It was about urban art and lowbrow art. In Europe they call lowbrow art "street art" now. This is a sort of the street art show. I was asked to do what they call a Proust Questionnaire, which you used to, you often see in the back of *Vanity Fair* magazine when they ask a celebrity a bunch of questions about themselves. Are you familiar with Proust Questionnaires?

GJ: Yes.

CK: Well, for those who aren't, it's just they ask you who's the most inspirational person in your life and what scares you the most and what color is your favorite color. These kinds of little questions are supposed to help people get a fix on your personality.

They sent me this Proust Questionnaire, which was going to be published in the catalog along with my biographical information. Every artist in the exhibition got [a catalog], I assume. I never did get my show catalog, by the way. They never sent it to me. This was after my work was taken out of the show.

Some Leftist, antifa blog in Paris picked up the story, and published their comments about me, which caused the

people that run the venue where the show was being presented to ask the curators to remove my work. When I got the email from them about this, I was livid! I wrote a little statement back to them, and I had no more communication about the issue with them until I received my work back in the mail.

I never got to read my Proust Questionnaire, which I had to revise. They had a problem with the first one I submitted. I never got the catalog sent to me. That was part of the deal. I was going to get a free catalog, a contributor's catalog.

And then I never heard another word again from these two editors of an art magazine in Paris called *Hey!* I just assumed because they're French they are... Obviously they are upset with me, I guess. I didn't even want to deal with them anymore. So, I didn't write back.

I sent them a statement about cultural Marxism, and not wanting to march in Gramscian lockstep with the other artists in the show. It was an angry little thing, a little statement.

So, yeah, I got censored in France, where they have the Gayssot Law, which is a law about Holocaust denial, that they mentioned. The curators said it's illegal for us to ... I guess they were telling me it's guilt by association. If we have a Holocaust denier in our show, we are somehow liable, too, for this. They brought up this Gayssot Law, as part of the reason why they censored me.

GJ: I think you also mentioned that various museums where your work is displayed have started putting up warning labels, sort of like parental guidance warnings.

CK: At the Sacramento Museum, somebody that I know took a picture with their cell phone of the new identification tag alongside a piece of mine that was donated to their collection. There's a qualifier about me being recently

outed as a Holocaust denier. I don't know why they had to put that on this identification card. Because of what? Their display has nothing to do with the Holocaust. But there I am. It's Charles Krafft. They mention this NPR business. I was on NPR. So, that's the only instance I know where they're starting to put warning labels on my art.

GJ: Well maybe you should just incorporate warning labels as a kind of design motif in your future work. Why not get out ahead of this—own it?

CK: Well, you know that I can do just about anything I want in the way of *épater la bourgeoisie*. The cat's out of the bag! What have I got to lose?

GJ: Right, right. So, tell us a little bit about the positive and the negative consequences of all of this for you. Tell us first a bit about some of the personal fallout. I understand that there was some relationship drama. Family drama, things like that.

CK: Yes, there's some family drama, which I won't go into too really seriously. Relationship drama, I'll probably steer clear of that, too. I did get some letters from people, from old friends. And they were lecturing me on my morality and calling into question my sense of good and my sense of decency. They think that not believing the received history of the Holocaust is indecent. So, they let me know how indecent they felt that was. And one of them had CC'd his whole family. He's got grown children, so each of the children got this letter, this email, that he sent to me expressing his disappointment in my moral failings. I didn't get a Christmas card from those people this year, I noticed. So, there's that.
Then an old teacher that I had been corresponding with over the last 40 years, whom I had as my freshman English

teacher in college, wrote me a letter and said we could no longer be friends—as a result of what he'd read about me in the newspapers. I don't know how to describe this letter other than that it was a rather final write-off of this friendship, this correspondence and ongoing friendship that we'd had since 1966, when I first met him.

GJ: That's amazing. Did you make any new friends?

CK: Yeah, well, I made a lot of new friends—not a lot, because there's not a lot of us—but within the, let's call it the White Nationalist movement, people actually sat down at their computers, most of them, found out where they could contact me, and sent me letters of support, emails that said, "I'm glad that you're standing up for yourself and not letting these people get you down."

I appreciated that. I got a couple of letters, believe it or not, from readers of the local newspaper, who put stamps on envelopes and sent me letters of support. I don't know who these guys are, but they took the time to let me know they felt I'd been kind of smeared, and they didn't like it. They believed that I should be allowed to say whatever I felt about anything. I mean, we have a First Amendment in the United States.

These letters and emails of support sort of drifted in. I appreciated the time that people actually took to sit down and address me personally. In this day and age when somebody does that, it's meaningful.

GJ: Oh, definitely! Very few people write letters anymore so when they do that, it's a sign of something.

CK: Yes, it really is. It's a sign of commitment to an old-fashioned way of expressing your opinion and support of a person. So, there was that. And then I got a big spike in Facebook friend requests from people that are sort of in our

camp. And so I approved all of those. I engaged in conversations with other artists, some of whom are sort of out-of-the-closet on their politics. And then others, who sent me messages that they regretted that they couldn't come out of the closet about how they really felt about things, because of their professional careers, and their academic careers. A lot of college kids, they seemed to be really worried, if somebody finds out what they really think about things. As they're going through school getting brainwashed by these teachers of theirs.

So, that was an upshot of this. I think that the positive actually outweighed the negative, to tell you the truth. I mean, there was a lot of negative ink spilled about me, but on a personal level I got more positive responses than I did negative ones.

GJ: Well that's great. Was this personally difficult for you? I imagine you kind of dreaded looking at your emails for a while.

CK: Yes, I did. I dreaded it. What I did was, there's a Google search option that you can use for Google to harvest anything that comes through them about a subject or a person that you want to know more about. Or a news item. I put my name in the Google search box for any articles about Charles Krafft. And every day there was a new one! I'd go, "Oh my God." I'd go there, and I'd look. There's always the same kind of smear.

Yeah, I did dread the Google search notifications, that there had been another article somewhere about me, because I'd have to go and read it. What happens is, it's like a circle-jerk. And you find this when you're reading books, too. Especially history books. People will use whatever people have said and repeat a falsehood. It's almost impossible to correct. I could have gone to the comment sections in the places where these articles appeared and corrected

them on certain things, but I just finally felt it was a waste of time. There was so much that was so wrong, I couldn't spend the rest of my day just trying to put out fires.

So, I just let it all slide, except for the *Vice* interview. There was a *Vice* London guy, called me up on the telephone trans-Atlantically and wanted an interview. Which I gave to him. And then once he got it in the pipeline and posted on *Vice*, I really didn't like it. He put words into my mouth, and he used English colloquialisms that I don't use and made me look like an awful person. So, I did actually go in and make a comment at that particular site about the way he had managed to mangle his story. But that was it. I steered clear of trying to defend myself in these places. It's just a waste of time.

GJ: Right, right. The number of people who can generate nonsense about you is pretty much infinite, compared to your ability to answer all of this nonsense.

CK: Yeah, you just can't answer it all. Like I said, to get back to this thing about . . . One person will say one thing, and then the next hack journalist, or hack blogger, will pick up that thing and repeat it. So, it gets repeated over, and over, and over again. Sometimes they'll add their two cents to this repetition until it's nothing like what it was. It's like that thing where you play a game where you whisper something into somebody's ear, and they're supposed to whisper it to the next person, who whispers it to the next person. Then finally, at the end of the game, what started out as the secret turns out to be something completely else.

GJ: There's a story about the UN, where the English phrase, "The spirit is willing, but the flesh is weak," was translated by the translation team into all these different languages. And when it got translated back into English, it was: "The wine is good, but the meat is rotten."

CK: Yeah.

GJ: So, what are some of the professional consequences of this? Has this hurt you economically?

CK: Well, no, it hasn't hurt me economically. However, I was working on a commission when the story broke, for a local guy, who then refused to pay me for what I'd made for him. He had requested three objects, which I had gone ahead and done for him. I wouldn't have done them otherwise, in the manner in which he wanted them. So, I call that a commission. He said, "Somebody's just told me about some press that you've gotten recently, and I'd like to ask you some questions." I said, "Well fine, but let's keep this about business. We have a business relationship here. I don't want to get into philosophy and religion and politics. Let's stay away from it." I never heard back from him, and he never came to pay me for what I'd made for him. It was really a cold kind of dismissal.

GJ: Did you deliver the stuff to him? Or did you . . .

CK: No, no, no! I said, "Your stuff is ready." I had taken photographs of it, and then I never heard again from him. This is after he said he wanted to ask me some questions, and I said, "Yes, I'll answer them. But I don't want to. Our relationship is not about religion or politics. Ours is about business." And then I never heard back again from him. And he never paid me for what I did.

GJ: Did you manage to sell it to somebody else?

CK: Yes, I did. I turned around immediately, and I sold the three pieces I made for him to a collector in France.

GJ: Well, great. Great! So, that's a wash.

CK: Yes. But the way the guy did it, it really was impolite. And unprofessional. And I disliked it so much I thought I'd write him a note about how I felt. Then, I thought, "Well no." I don't want to let him know that I even think this about him. I didn't want to waste any more time with this fool. So, I didn't send him a letter. He should have said, "Well, I can't go on with your politics." Or "I can't have this stuff in my home now that you've been blackballed by the community." He just quit communicating.

GJ: So, over all though, can you say that in 2013 your business, your purely business aspect of your artwork, was up or down, or pretty much the same?

CK: It was pretty much the same, with a little bit of a spike.

GJ: That's great. Did you get new commissions from people who were sympathetic?

CK: Yes, I did. I got commissions from people that felt that it would be a way to support me, and they were sympathetic. They enjoyed my art, and they said, "Now is the time I'd like to buy some." They made a kind of a commitment as a result of the press I got.

GJ: That's great. That's really great.

CK: Yeah. I've appreciated that. We're talking here about four or five people that did this. Actually stepped up to the plate and bought some art from me as a result of the interview that I did with you earlier. You know, the two interviews around that time?

GJ: Right.

CK: They'd heard them!

GJ: That's great. That's great. The enemy tries to destroy people by destroying their livelihoods. And it's important to know that when you're an independent businessman, you are somewhat immune to that. You might lose some customers, but other people, if they hear about this and get incensed by the injustice, are going to step up and try and make sure that they can't hurt you. That kind of solidarity within our sphere is a really positive sign, I think.

CK: I do too, and I can't thank these people enough for helping me out.

GJ: So, Charlie, tell me about the artists. Obviously, you don't want to name names. But tell me about some of the artists that you have been contacted by. And has this spawned any new artistic collaborations or projects?

CK: I think it might be best for me not to mention names of artists, but I got contacted by White Rabbit Radio.

GJ: Right.

CK: And, as a result of that, I'm sort of working with the artist that does the graphics for Horus the Avenger. He's sort of the in-house artist there. He lives in Kentucky. He and I are working on a project now, together.

Horus, himself, he bought a piece from me. He's one of these people that heard the interview. Actually wanted to purchase something for his collection. Did so, and now I'm talking to him about another piece that I'm making especially for him.

Those guys are fully committed members of this White Nationalist community, and they're very supportive. So, I appreciate it. And I'm glad I'm in touch with them, because

it's just nice to have other people that are art makers and culture makers to talk to about business. We're tradesmen! I'm always looking for other people that are in the same kind of trade I'm in, just to talk about it. I like what I do, and if they like what they do, it's fun to compare notes. And ideas.

GJ: One of the things that I really want to try to encourage, in whatever small way I can with *Counter-Currents*, is the kind of artistic subculture that existed on the Right in the first half of the twentieth century. There was a lot of excitement! There were a lot of great artists, and poets, who were involved with this. And there were all these amazing manifestos from the Futurists, and the Vorticists, people like Marinetti, Wyndham Lewis. I would like to see more of that in the future, in the twenty-first century.

Do you think anything like that sort of artistic subculture or movement might be helped along by some of this exposure that you've gotten and some of the networking that has taken place since then?

CK: Yes. I think eventually something will be done, because I remember zines coming out, before even the age of the computer. Were you around? Did you ever subscribe to any of these zines that people were self-publishing, magazines?

GJ: Well, I was sort of late to all of this, so that was more like mid-1990s.

CK: Yeah.

GJ: And it kind of died with the internet. I remember reading copies after it had stopped publishing. I remember reading *Answer Me*, the Jim Goad zine. That was pretty amazing stuff.

CK: Yeah, that was. Well, that's exactly what I'm leading up to. Goad's magazine, *Answer Me*, came out of the zine culture. It was pretty nicely published, and it ended up on magazine racks in places like Tower Records.

Well, I recall even back then, music zines having discussions about fascism and occultism. And music and fascism. And occultism and music. In this mix, you see, of music, occultism, and fascism, and National Socialism. That's where I started learning about these artists from Europe, who had been completely swept under the carpet after 1945.

I'd never heard of any of these people. Ernst Jünger, for example. How would I have ever found out about Ernst Jünger if I hadn't been reading neofolk zines, you know?

GJ: Right.

CK: There's a list of names of people that we could go over that I discovered through this little self-publishing world, which was transposed into internet blogging where you can go and find out about it. I think, yeah, it would be nice if something like *Answer Me*, with that much of an audience, a national audience, kind of like a mainstream newsstand audience. Or a mainstream bookstore audience. I think that we might build up a critical mass, eventually.

We could have a magazine like that. That's the way *Juxtapoz* started. It was a reaction against these academic art magazines that everybody was just bored to tears with. *Art in America*, and some of these other highbrow art magazines, initiated *Juxtapoz*. And then *Juxtapoz* led to *Hi-Fructose* magazine, and it opened up a whole new window into another area of art-making that the mainstream art magazines were completely clueless about.

I think if there's enough people with time to sit down and put together, to curate their interests, and to write about their interests, we might be able to get something

going. An anthology. It would be probably kind of a pioneering thing, too. Because I tend to think that more and more people that read books and think about things more seriously than most, are starting to see through what we're being presented by the mainstream media, in the way of dialogue. God, these news stories, and discussions about culture and politics. A lot of people can see right through it.

A lot of people quit watching television, I know. The *New York Times* . . . People are no longer grabbing the Sunday *Times*—they'd spend the Sunday in bed with it—because they know there's a lot of BS going on there.

GJ: I think the system is sort of losing its grip on people's minds. I don't think a lot of people are willing to affirm an alternative yet, but they do know down deep inside, that what they're getting is a thinner and thinner PC gruel—and it's not healthy for them.

CK: Yes, and I think a lot of the cultural mavens are being exposed as having feet of clay. Noam Chomsky, for example, people are beginning to think, "Well yes, he's a gatekeeper." Smart people are starting to figure out who has been precision placed to keep us sort of in a mental box about issues. I see people waking up all over the net.

But, then again, I spend my time on the internet in all these oddball places. I'm way off in the fringe looking for more and more eccentric art and commentary.

I'm not a good example of a person that is balanced anymore, because I've swung way, way, way over to the fringe. Center Leftist, center Rightist—I'm not interested anymore. I'm interested in extremism, and I'm not ashamed to say it. That's where I find the most excitement in writing and in art-making.

GJ: Well, that's where culture is created. It's in the extremes. No culture is created in the center. Unless it's junk culture. Lawrence Welk kitsch, and things like that.

Your Facebook feed, I might add, is a great source for me. In my conversations with you over the years—you can attest to this—I always carry around a notebook, and I'm always jotting down names of artists and museums and books and things like that. Because you are just indefatigable in turning up interesting new stuff. Every time I talk to you, the world gets bigger. So, I really appreciate that. Your Facebook feed gives that to me on a daily basis.

CK: Oh well thanks! On my Facebook feed, I'm essentially just sharing my own discoveries. It's not like I know all this already. I spend time sort of exploring, and then when I find something interesting, I hurry up and want to share it. That's the way I've been all my life. When something excites me, my immediate reaction is to tap somebody on the shoulder next to me and say, "Hey, get a load of this! Isn't this interesting?"

I've always been kind of eager to just share what I've found out about this and that. That's why it's hard for me to keep a secret. It's hard for me to fly below the radar.

GJ: Well it's really amusing. When they finally outed you in 2013, I did a search for you on the internet to get background to do the interview with you and the articles that I wrote. I remember in 2005, in 2008—I think those were the years—you were given a reward for writing an essay on some Holocaust hoax. You did an interview on this stuff. This stuff was floating around out there a long, long time ago. You weren't trying to keep it secret, really. But it took Jen Graves eight years or so to finally catch up with this and start jumping up and down and pointing at the witch! I thought "It's not a well-kept secret."

CK: No. It wasn't.

GJ: You were hidden out there in plain view.

CK: Last night I was reading something about Mircea Eliade. Somebody was writing a book about Portugal during the war, and I knew that Eliade had been to Portugal. So, I did this search on Eliade and Portugal. I landed on this blog. It's called "Politics and Metaphysics." There was an article there on Eliade. I read this thing. And then, I went down to the comment section. I'm reading the comments, and I'm totally intrigued by the whole thing, and then I came to one of my own comments that I'd left there in 2009! I didn't even remember reading the article or leaving the comment. And you know, it was a pretty good comment. I was really surprised . . . surprised myself. I said, "Geez, you've been here before and forgot all about it."

GJ: That has happened to me. I've used so many pen names over the years. I remember doing a Google search on something, and I clicked it and started reading, and thought, "This is really good!" And then I suddenly realized, "Oh, I wrote this!"

CK: I wrote this! Yeah, that's happened to me.

GJ: Well, Charlie, I want to just make a promise here, or an offer. I've got a full plate at *Counter-Currents*. But I would be willing to publish something that would be like an annual, or a zine, or whatever, if it would be a forum for people who are artists today, who want to make statements, and do analyses, and issue manifestos. And also, a historical study of great artists of the past, if that would in any way contribute to the fertilization of a New Right artistic subculture.

I think that would be a tremendous contribution. It's

one of the things I want to do. I don't know what form it would take. I would probably like it to be sort of a larger coffee table-sized thing, or like a magazine-sized thing. Like these *Hi-Fructose* volumes, and other volumes like that. I have a lot of those.

Anyway, if there are people listening who are into this sort of thing, and if you're interested in something like this, if you want to edit or curate a project like this, *Counter-Currents* will make it happen.

CK: The seminal books that I remember that actually had an impact on me, from the 1990s, were little anthologies. One of them was *Apocalypse Culture*. Do you remember seeing that?

GJ: Oh, yes. Those had a huge influence on me.

CK: He did a follow-up, about a decade later, *Apocalypse Culture II*. Just that little collection of weirdness that Adam Parfrey put between covers, it really had an impact on a lot of people, as did those *RE/Search* anthologies that were coming out of San Francisco on strange music and strange film and neo-primitivism and tattooing and piercings, that kind of thing.

GJ: Right.

CK: And interviews with oddballs, that they conducted there. These fringe characters that they'd unearth and get to talk for the first time to another generation of people. Esquivel, I don't know if you've ever heard of him?

GJ: Oh, yeah.

CK: Or Korla Pandit, an old organ player who'd go around the country in the 1950s and play the organ. In a

turban! They go find these crazy guys that have been sort of celebrities in their day, but time had passed them over. Then, put them between covers and they became cool again, all of a sudden. Martin Denny, the *Exotica* stuff . . .

GJ: Right.

CK: Well, if we could somehow package a collection of interviews, essays, and photographs, and art pieces, that would relate to what we're interested in, I think we might be able to make some sort of a dent, you know. Maybe in whatever is on the shelf next to the kids in the college dormitories. That's where I'd like to see it.

GJ: Exactly. Get something out there that's just mind-expanding and fertilizing for the imagination. I really do have to give Adam Parfrey a lot of credit for the *Apocalypse Culture* volumes, because they really did have that effect. Some of the stuff he published was so funny that I threw my back out laughing at it.

CK: Well, he's still provoking people with his publications. David Cole is coming out with a book in the spring. It's called *Republican Party Animal*.

GJ: Okay.

CK: I don't know if you know about it . . .

GJ: Oh, I know about David Cole, yes. That sounds like a really . . . Is this a Feral House publication?

CK: Yes. David Cole is going to talk about himself and his career, so I'm looking forward to hearing all about that.

GJ: I guess the title *Republican Party Reptile* was already

taken by P. J. O'Rourke.

CK: Oh, really? I'm really interested to find out who in Hollywood is a Republican, by the way.

GJ: That would be a really interesting question, although the Republicans are so useless anyway. It almost doesn't matter.

CK: Yes, just anybody there that's a reactionary to the usual Hollywood Leftist agenda.

GJ: So, let's sum up, Charlie. This has been a really enjoyable conversation. If somebody is out there in Radioland who's thinking of taking the plunge, and becoming a little more open about his political views and being an explicit White Nationalist, what advice would you give him?

CK: Run that by me again?

GJ: Based on your experience over the last nearly one year, if somebody is out there who is thinking of becoming more open about his political activism, under his own name—or if somebody out there, who doesn't want the publicity is about to get the bomb dropped on him by some other alternative weekly—can you give those people a little bit of advice about how to handle it? How you've handled it? And is it so bad?

CK: You're going to have to ask yourself how much time do you want to waste talking to idiots. Because you're going to get approached by people that are not only upset with your views, they think that they are immoral and out of line. But they're probably not as well-read as you, or aware of how you arrived at your opinions.

When they come, you've got to remember that they're

not as well-versed in the subject as you are. You have to ask yourself, how much time do you want to spend trying to educate these people, who are there to do you harm anyway. That's one thing I'd like to get across.

The second thing is, it's going to blow over if it's a big storm. It only lasts a while, because they have to get on other news. And you're going to be yesterday's fish wrap soon enough.

Friends and family: you're going to have to be probably pretty strong in your commitment to your beliefs, because you don't want to hurt people's feelings that are close to you, and they do get hurt by the peer pressure that they get. This guilt by association trip that gets laid on anybody that is close to you that is open to attack.

The social sphere is the worst. Professionally, if you're self-employed, I wouldn't waste too much time about losing your job, really. If you work in a corporate office kind of context, there's human resources, those people are deadly. You're going to have to worry about that, probably. It might even be a good idea just to keep it under your hat, what you think, if you're in the corporate sphere.

I don't know what else to say, other than you can't turn back once you've amassed a certain amount of information about something, and you know that what you've learned is probably the truth. How can you just go back after you've come into more truth than you had before? You're just going to have to live with it, and if it gets really tough you can read about these other people that had a harder time than you did.

For God's sake, back in the 1950s and the 1940s, some of the people that were talking about the stuff that we're talking about were hounded out of their jobs. Some of them were brought to trial. We're not talking about the blacklisting, either. We're talking about the people on the other side of the fence: anti-Semitic preachers and anti-integrationists in the South. Intellectuals. People that were actually

college-educated, non-civil rights participants and activists who spoke up were pilloried. They probably had a lot tougher time than I ever had. So, when you do get in this position, which is scary at first, just remember that you're not the only one that it's happened to, and you're not going to be hung, for God's sake. We have a little bit more leeway in America with our First Amendment rights than they do in Europe, so it's not going to be as bad.

The social thing is the worst. When you have friends that disavow themselves from you, or the gossip starts up and some of it gets back to you, that can be kind of hurtful. Be prepared for getting your feelings hurt.

GJ: Overall, though, do you have any regrets over this? Or do you think that your life is, on balance, better or worse than it was a year ago?

CK: I think my life is better than it was a year ago. I was never really trying to conceal anything, as you noticed when you went back to check on me. The cultural Marxist gatekeepers of the community here in Seattle—we're very liberal here; this newspaper is extremely liberal, and they needed to sell papers—they've learned that they can sell more papers when they generate a scandal.

After they got done with me, they went after a florist in town who had refused to sell flowers to a gay couple, for a gay wedding. That was the next big story that they wrote up for the rest of the month. They needed a sacrificial goat. And they chose me, and that's that.

I knew who I was up against, and there really wasn't too much I could do about it. It was kind of revealing to look at. I generated that article here, about 350 comments, from people that are in the arts, and I couldn't believe how thick some of these folks are! I mean, they're supposed to be educated. They're supposed to be curious. And they're supposed to be talented. And God are they stupid! I knew that

Joe Six-pack was kind of thick, with his preoccupation with Saturday afternoon professional sports and all that. But I had no idea the extent of the retardation of some of these people here that are in the arts. It was amazing: what they think, and to see some of these guys come out swinging. It was just really entertaining.

GJ: There is nothing more vile and absurd than these vulgar, middlebrow, pseudo-intellectuals.

CK: Oh, God.

GJ: They are really, really thick. Thick as two short planks. And so full of themselves, that's the other thing. Not only are they ignorant, but they sling that word around at us all the time. "Oh, you're just ignorant!"

CK: Yeah!

GJ: "This is ignorance!" It's just laughable! These people have never thought original thoughts in their lives. Have never read anything outside the *New York Times* bestseller list, or beyond their college syllabi. And they have the face to accuse us, without missing a beat, of ignorance. They've been programmed that way.

CK: Ignorance, and bigotry, and . . .

GJ: Prejudice.

CK: And prejudice, yes. They called me a cranky white guy chasing immigrants off my lawn with a golf club!

GJ: Charlie, this has been a great, great interview. Any last words before we wrap up?

CK: I don't have any last words other than, back to this idea of putting together some kind of a publication, we

should ask the people that are interested. They can do it under a pseudonym, if they'd like to, and maybe we could have them get in touch with either you or me.

GJ: Exactly.

CK: Let's just put the word out that if you've got something you want to share, and you think we might be able to use it in this context. Let's just say we're going to shoot for a one-issue anthology, for beginners. Let's not say it's going to be anything other than that, really. To go ahead and let us know what it is you'd like to share. And then we'll look it over, and we'll get back to you. Does that sound reasonable?

GJ: Yes.

CK: Because I'd like to do this too. I think it would be fun to have an anthology of writing on contemporary culture coming from our position, instead of this Marxist position.

GJ: Alright, well, I can hardly wait to have you back for another episode of *Counter-Currents Radio*. So, thank you, Charles Krafft.

CK: Well, thank you for having me again, Greg. Thanks for being a good explicator the last time around, when I was in such deep doo-doo. You were the only one that really—you and Carolyn Yeager, believe it or not—gave me a platform. Everything else was pretty negative. Anyway, I'd like to thank you for letting me be on the program.

GJ: All right. Well this, I hope, is just one of many, many more appearances. So, take care.

CK: Okay, thank you.

The Handshake

February 27, 2014

Young artists, covered in tattoos sporting half a haircut, come up to me all the time when I'm out and say, "Charlie, you are such a fat, bald, and unpleasant old fuck, but you are so successful. How the heck do you do it!?" And I always tell them. "It's in the handshake, kiddo." Let me share my secret with YOU.

Both men and women should have a good, firm handshake. Always begin and end your meeting with a new client (and all follow-up meetings) with a firm and friendly handshake. This is usually the first gesture between two people, and if it is not a strong beginning, your meeting will be off right from the start. When you meet art gallery representatives, also begin and end your meetings with a handshake. You often can tell how enthusiastic people are by the way they relate to you through their handshake.

A handshake should be firm but not hard. It should be given with a warm smile.

It should not be an uncomfortable squeeze.

It should be short and to the point. Do not hold on. People who hold on to another person's hand may make that person feel uncomfortable. Sometimes people will do this as a way of holding your attention. If a client does this to you, it is best to grin and bear it. But don't do this to a client or gallery representative.

A handshake should not communicate in any way that one person is superior to the other. Do not squeeze the other's fingers.

Get a good grip of the entire hand, and if you don't get a good grip, do it over.

The "wet fish"

This is what we used to call a limp, soft handshake. When someone does this to you, you get the impression that the person is not really interested in having a strong connection, does not want to make a good impression, or is indifferent. Some women do this because they think it is more gentle and feminine. It is not a good idea to do this. The "wet fish" communicates weakness of character.

The power squeeze

Some men like to show off their physical strength when shaking the hand of another man. It communicates superiority and the desire to dominate. It does not communicate sincerity and warmth, but just the opposite; it communicates cold, hard domination. If you have a strong grip, be careful how you use it.

The finger crusher

This happens when someone squeezes the fingers of another. It is not a handclasp but a finger crunch. The person on the receiving end feels put off and a little cheated. Sometimes it can happen when one clasps the other's hand too soon. (Be sure that the flesh between the thumbs and the first fingers is touching before the hands close.) When I get one of these handshakes, I say quickly, "Let's do that again." At the same time, I gently take hold of the other person's wrist, release my hand, and push it into the other person's hand quickly before he or she knows what's happening. That way we get a good handshake and start our meeting on a positive note.

The dominant/subordinate handshake

This happens when one of the parties has his hand on top of the other person's. Usually, he comes in for the handshake with a circular motion from above. His hand

comes down onto the other person's. The dominant person has his hand on top of the subordinate person's. It is done quickly, and the nonverbal message is that the person with the hand on top is dominating. If someone does this to you, simply straighten out your hand so that the dominant hand will be vertical alongside your own.

The friendly, warm handshake

The best handshake is the friendly, warm handshake, in which both parties clasp hands in a firm way. Both hands are vertical with their fingers pointing to the other person. The two clasps are equally firm—not squeezing, but firm. The shake is brief, friendly, and the two parties look each other in the eye and say, "How do you do?" or, "I'm very glad to meet you." Usually, names are exchanged at the same time. It is the proper way today between two men, two women, or a man and a woman.

The London Forum Speech

November 27, 2015

When I heard that Charlie had an upcoming exhibition in London, I put him in touch with Jez Turner of the London Forum, because I thought Charlie would be an excellent guest. The exhibition was canceled due to Leftist protests, but the London Forum appearance was a big success. I wish to thank Jez Turner and the London Forum team for making this event possible, Buttercup Dew for finding a copy of the video after it had been deleted from YouTube, and Hyacinth Bouquet for the transcription.

Jez Turner: He is a multi-media artist known for his work in porcelain, and he's here in London for an exhibition of his work, his third exhibition in London. But the current exhibition was canceled after threats of violence were made against the gallery by assorted Zionist thugs. He has kindly agreed to speak to today's London Forum about his life, his work, and his experiences. So please give a very warm, English welcome to a very talented artist, a very talented craftsman, Charles Krafft.

Charles Krafft: Thank you very much, and it's a pleasure to be among allies. I don't really have a prepared speech for you, but I have some notes that I took while I was listening to the other speaker, and I have a few issues that I'd like to bring up, which I'll do, after I get done telling you what happened to me this week at StolenSpace Gallery in Whitechapel.

I'd been working for the last seven months preparing an exhibition. I work in slip cast blue and white porcelain. I

learned this technique from studying Delftware, both English and Dutch. What I've done with the Dutch and English Delft tradition, of blue and white surface decoration of pottery, is sort of turn it upside down and make it controversial by commemorating people like Nick Griffin.

My last show in London was all teapots, and it was called "Pitchfork Pals." It was a series of dictators, media personalities that are reviled, and serial killers. I worked for a year on that. These come as a piggybank, a bust, a teapot, a Toby Jug, and that's it. That's what was on display, and I thought, when I prepared that last show before this one, that because the English drink tea, they would buy these crazy teapots. Well, nobody bought anything! It was a complete bust at this gallery.

I had some perfume that I created called Forgiveness. The Forgiveness comes in a small bottle, a very nice crystal bottle, and it has a stopper like a perfume bottle does, very elegant. It's a swastika. A swastika, and then "forgiveness" across it. I also exhibited bars of soap. Had a whole line of beauty products that included the Forgiveness perfume, the Forgiveness soap, and then an advertising campaign that went along with it.

There was absolutely no problem at that particular time, 2010, when I put that show on. There was a little bit of disappointment for me, because I'd spent so much time working on it, and I'd kind of customized the exhibition for England, with the teapot. Then I didn't sell anything, but that's fine. I don't expect sell-out shows.

I went back, and the gallery wanted me to come back, and I kept putting them off because I had other obligations. Finally, I said, "Yes, I'll put together another show for you." I had to think about what to do, because, in the interim between 2010 and today, 2015, I was outed as a Holocaust "denier" and a White Nationalist.

I come from Seattle, Washington. A local critic there had been notified of some anti-Semitic comments on my

Facebook feed. So this all generated from social media, which is something that I wasn't really familiar with. I sort of came into social media through the back door. I'm from a different generation. I don't have a cell phone. Some kid that likes my art thought it would be good for me to get on Facebook, and so he made me a Facebook page, and I was on there expressing myself.

This psychology professor at a local university took umbrage with these rather crude comments that were appearing on my feed, and she thought that it was me as a sock-puppet. It wasn't me. I got this message. If you do Facebook there's this message app. You can get private messages from your Facebook friends. This woman said, "I can't believe the Seattle art community puts up with you with these kinds of comments that are appearing on your Facebook page." I wrote her back, and said, "That's not me at all! I just don't like censorship. I don't want to be here monitoring what people have to say about what I'm posting. This person, you don't like his language, or you don't like his attitude, his politics? I'm sorry, but I'm not going to censor it."

My girlfriend was concerned, too. She said, "You've got to stop these people on your Facebook page making this kind of gutter anti-Semitism." I said, "I don't want to do that. I'm not a censor. They can say whatever they want." I let it go.

Finally, the local critic emailed me and said, "I've received an anonymous email from someone in the community who said you don't believe in the Holocaust. Do you care to comment on that?" I said, "No, I care not to comment on it, unless it has something to do with some art that I have on display somewhere that you would like extra information about." Because, this is a no-win situation for me. If you write that I'm a Holocaust heretic, it's like being called a pedophile. There is no way to get out from underneath these charges once the media has tar-brushed you with this smear.

Of course, nobody wants to listen to why you have skepticism about the Holocaust. They just want to smear you, and they need to hang a story on a scandal. It sells more newspapers. I said, "I don't want to comment about this. It's a no-win situation for me. No, I don't want to make a statement about it." She said, "Fine. Fair enough."

Eight months went by. I was in India at the Kumbha Mela, which is a great big Hindu spiritual festival that they hold every 12 years, at this one particular confluence of the three biggest rivers in India. I'm trying to spiritual, you know. I want to be with the yogis, and all this. I get the email—I have my computer with me there—and it's that woman again, in Seattle. She said, "Listen, I've decided I'm going to go ahead with this story about you, and you can either answer some of my questions, or you can just forget about it, but I am going to write about your politics." I said, "Okay, fine and dandy, send me the questions."

I got this list of questions, which I answered honestly. Within two weeks there was a big article, "Charles Krafft is a White Nationalist Who Believes the Holocaust Was Exaggerated." She had polled these people in the community who knew me. The gist of the story, as she presented it to the world . . . It became viral. It went from Seattle, Washington . . . I wasn't even worried about it. I thought it was going to be a local issue. It would die out. It's a small paper. But it got picked up the *Huffington Post* first, and the U.K., *The Guardian*, and *Vice*. It went all the way around the world, because of this Holocaust business. They made me look like I was an art celebrity. Well, I'm not an art celebrity. I'm just one of thousands of artists that try to make a living making objects with their hands.

They had me all pumped up, as if I'm sitting on some great academic, on a cultural pedestal so that they can knock me down.

The story would not stop, and my response was to do nothing; except, I did say "yes" to anyone who wanted to

interview me. Either in print, about the scandal, or on a podcast. And I made no bones about their politics. The only people that were really interested in hearing my side of the story were nationalists, so I ended up doing about four podcasts with groups in the cyberspace who are nationalists.

That, of course, it leaves a trail. Anybody who wants to look into my case can go on Google, and then there I am, with my name, and it's Charles Krafft: *Stormfront*. Charles Krafft: *Counter-Currents*. Charles Krafft: *Rebel Media*. Charles Krafft: wherever I spoke to anybody who was interested in hearing about what had happened to me. So, yeah, I guess I am now. I'm a Holocaust denier and a White Nationalist. I'm so sorry!

Back to the StolenSpace Gallery in Whitechapel: these people are kind of naïve, I guess. The gal that runs the space there, she said in a statement that was posted at their gallery website, after she canceled the show, she said, "We didn't realize at the time we invited Charles back to have his third show, that this controversy would follow him here."

What happened was that I was in the gallery on the second day of my arrival, unpacking my work and getting it ready to hang, and the director told me that she had been getting phone calls. The gallery had been receiving phone calls from people threatening some sort of protest. As they threatened the protest they're saying, "We can't guarantee, if we protest, there won't be violence." So, she assumes that there is going to be some violence. But it's only implied, and it's only implied that there will be a protest, too.

There's the social media among some artists, I just learned this, *Not Banksy*. It's an alternative website for kids that like to go around tagging up the public space with their graffiti. They have issues there that they discuss, and somebody started a thread at that particular place called, *This is Not Banksy*: "Charles Krafft at StolenSpace. You've got to be fucking kidding me!" Then it started. They've got five pages

of young, Left-leaning, anarchists, socialists, graffiti punks that have decided that I'm evil because I have some skepticism about the received history of the Holocaust, and I stand up for my own race on racial issues.

This woman at the gallery decided that this was too much. She said, "I'm going to have to hire some security." At first she was going to stand up against it. I thought, "These are trolls!" These are trolls. These are young kids. They're sitting at their computers. Nobody's going to come to the gallery. Nobody's going to assault anybody. It's just a bunch of SJWs, they call them in America, Social Justice Warriors. They are young guys, and sometimes girls, that have these boring jobs, maybe working in a cubicle somewhere in an office. If they even have a job. They have a commitment to some sort of Left-leaning socialist ideology, maybe in a network. And they get together, and they do these swarm attacks that are all happening in cyberspace. They don't happen on the street, really, although, they do happen on the street. I was trying to put the fire out there at the gallery, to convince these people that what we have is just a bunch of kids here; this is mischief! We don't have to worry about getting hurt. Well anyway, they shut it down. So that's that.

I don't know what to do about it. There is not too much I can do about it. I'm having the gallery send the work back to me, at their own expense. I didn't lose my temper, really, and I didn't express my disappointment. "Well okay," and sort of walked away. I don't know what else to tell you about this business.

This magazine, *Mjölnir*, is a cultural magazine for people on the right, and it's brand new. It's David Yorkshire's, and he did a bang-up job of writing, allowing me to have a bunch of space in there for this last issue. If you're interested in my story, which is given, you can pick up an issue from him and read about it. Yeah, this is the bombing of

Dresden [on the cover]. I started off commemorating disasters. The evolution of my art ideas is all in there.

I got the idea on commemorative china. You usually find something heroic or national: a national monument or a national hero. I thought, well, maybe it doesn't have to be so prosaic. I wanted to commemorate natural catastrophes: hurricanes, fires, earthquakes, and such. Airplane crashes. Murders.

Then I got politicized when I went to Slovenia, and I ended up in Sarajevo the night that the peace accords in Dayton were announced. Maybe I should explain to you. The Bosnian militiamen were patrolling the city. And I was with a band called Laibach. They are a rock band from Slovenia. I traveled with them to be their official tour photographer, because their tour photographer couldn't go, and I got the job.

I got the bright idea—looking at these Bosnian militiamen with Kalashnikovs strapped on their backs; they were in the theater, where we were putting on this concert, during the siege of Sarajevo, the very last day of the siege—to re-cast weaponry in porcelain.

That's kind of how I got famous. I created something called the Porcelain War Museum. It's an ongoing project. Just life-sized weapons, guns, automatic weapons, and pistols, in Delft. It looks just exactly like your granny's china, but it's a life-sized, detailed, automatic weapon usually. If I can get my hands on them, I cast these in plaster. Then I re-cast them in porcelain, and then I decorate them in blue and white.

Another thing I do that you might be interested in, is bone china, which was invented in England by Josiah Spode, in 1789, in Stoke-on-Trent. The reason it's called bone china is because it has calcinated cow bone ash in the clay body. I got my hands on the first formula for bone china, and I substituted the calcinated cow bone ash for human bone ash from the crematory. It's a chemical thing,

and they both do the same thing. Whether it's human or cow, it doesn't make any difference. You get this bone china out of it. That's why it's called bone china, not because it's white.

So I thought, "I'm going to revolutionize the funerary arts." I started advertising. I call this "Spone," after Spode and bone. My product is "Spone: Human Bone China." I took out ads in undertakers' magazines in the [inaudible] United States, and I paid for these. It's costly. A new way to commemorate your dead relatives, and loved ones, have them re-cast into a teapot, if you'd like! That went nowhere, too, I'm sorry to say. I made some interesting things for a few people, but it hasn't really caught on.

I've got a few pieces. I brought this stuff to give away to friends at my opening, because I expected to see people I know there and say, "Here, have one of these." Because I couldn't give them away at my opening, I have them on display here. If you buy one, we'll just give the money to Horst Mahler. Military lapel pins that I cast from real military lapel pins. Badges, cap badges. Spanish, Hungarian, and this really nice one—I wish I had more of these—it is the Artists Rifles regiment, which is a British artists' battalion that was mustered by Sir Edward Lord Leighton in 1867, to protect the city of London from Napoleon III. It's a great story, because they became the (British Army) SAS, eventually, after World War II. What they began as was just a bunch of ponces at the Royal Academy that wanted to dress up in uniform! They had kind of an illustrious career. They went through World War I, and in World War II they were subsumed in the 21st SAS. Anyway, it's a good story.

I've been involved in following the revisionist cause for a number of years. I came into revisionism through my interest in Romania and the Legion of the Archangel Michael, which became the Iron Guard, which was the paramilitary part of the Legion of the Archangel Michael, which was a nationalist movement of students in Romania that were

very aware of what was happening close by in Russia and how Bolshevism was creeping into Eastern Europe.

They protested against it, and some of their protests were violent. They had no compunction to shoot a person down in the street if they thought he was a traitor. The interesting thing about them is they shot Romanians, and they didn't shoot the Jewish industrialists and politicians that were actually collaborating with the Romanians in bringing in Bolshevism and left-leaning Marxist ideas about the traditions in Romania.

Codreanu was the head of it. He was a very charismatic Romanian college student: absolutely handsome, matinée idol good looks, and a committed Christian. He said, "If I had a pistol, and the enemy was in front of me, and then a traitor, who would I shoot first? Well, I would shoot the traitor first!"

So that's what they did. They took it upon themselves to assassinate certain leaders during the interwar period, and then they would turn themselves on the mercy of the court. That's another thing that they did. They didn't run away. They'd say, "Yes, well, we shot them. Now, we're prepared to take our punishment." These were a certain group of extremely committed Legionnaires that did this. They were called the Death Teams. The rest of the movement was more of a populist movement. It was political. They ran candidates. They opened various centers around Romania. When Romania entered World War II, they'd been put down in a *Putsch*, so they didn't have anything to do with the Holocaust.

When you go to a history book and you read about the Iron Guard, they have all this propaganda about them having been involved in the Romanian part of the Holocaust. I wanted to find out more about that. I took myself, twice, to Romania. I met with Catalin Codreanu, the youngest brother of Corneliu Codreanu. He was 92 years old when I met him. He'd never met an American, and he liked Ronald

Reagan. He wanted to know all about the "cowboy." I didn't know exactly what to tell him, because I'm not a Republican. He died, and his wife died. He went to prison, of course, after the war. They rounded up these Legionnaires before the war. They threw them into these dungeons. Then after the war, they were kept in these dungeons until 1965. They got an amnesty, and many of them were released.

Charles Krafft with Cătălin Zelea Codreanu and his artist wife Rodica in Bucharest 2000.

That's how I kind of drifted into revisionism, because a priest in America named Valerian Trifa had been the first poster-boy in America for deporting "Nazis." Nazis among us. I got very involved in trying to help clear his name, because once I understood what had happened to him, then I understood Jewish power and how this whole thing was a political game. The man had done nothing. He just had been the head of the Christian College Student's League during that particular time in Romania. Then he'd gone, sat

[World War II] out in Dachau concentration camp, immigrated to Italy, and then come to America.

Then, all of a sudden, this Jewish organization in New York City took it upon themselves to get this smear campaign going. It took them 27 years to finally get this guy out of the country. He said to his congregation, "I cannot ask you to help me fight the American government, the Immigration and Naturalization Services. Their pockets are boundless. They have more money than God!" This guy had to ask his congregation every year to help him hire a lawyer, so that he could go back and make his case for himself. He's a guy that got caught up in a terrible political game that has a lot more to do with Romania and America. "Free Trade," it was a trade agreement. I won't get into it.

Anyway, I wanted to clear his name. That's how I found out about the lies about the Holocaust. I went to Romania and found out everything you read about this terrible pogrom that they had in 1941, in Bucharest, where these Jews were murdered—well, my God, they just talk about the Jews—as many Romanians died the same day! It was anarchy in the streets.

One thing I wanted to bring up is jailed Holocaust revisionists. In the course of my studying revisionism and being involved in revisionism, I can never find out the addresses of the people that are in jail in Europe, from anybody. I'll write to David Irving, "Hey, how can I send a Christmas card to Horst Mahler?" Well, nobody can tell me! They don't know where he is, none of these people. I asked Mark Weber. You would think, the Institute for Historical Review [would know]. I said, "Hey, do you guys have a list? You're always whining about people going to jail for Holocaust heresy. Could we have a list of the heretics that are in jail so that we could either send them a card to decorate their sorry little cells in the prison they're being kept in? Or send them money for their families?"

I've ran up against a brick wall for years. I did get a list

going, but every year it changes. My list, I don't know how current it is today. I sent it to Irving, and he put it up over on his website. Well, what he's got there is like five years old. I don't think there's anybody left in jail on that list. I've talked to Germar Rudolf about this, who's taken over this magazine we have in America. It's called *Smith's Report*, and the CODOH website, for all you revisionists.[1] I asked Germar if we could have a list, so that it's always there, so that whenever you go for your information about revisionist news, there will be places to communicate with those guys.

Our soundman over there, Simon Shephard, got jailed in the United States. How was I going to find out where Simon was? It was crazy. I couldn't find out where Simon was. I wanted to send him some mail. I finally found him, but you guys were making me work too hard! I want a directory somewhere. Where I can find out where these people are being held, so that I could send them a Christmas card. If Christmas is coming up, we should get together and find out where they are, so that they can get cards.

Alright, jailed Holocaust revisionists, I want to know where they are in jail. Where's Sylvia Stolz? Is she in jail? She's at home? When she goes back in, we've got to find out where they're going to put her. Where's Ursula Haverbeck? Is she at home or in jail?

I did run up against kind of a brick wall with the revisionists, who I assumed would have this information, and they didn't seem eager to help me get it. I went to the Jewish organizations! They don't know where these people are. They're not that organized. Really. I tried.

Economic and social ostracism, when you're outed: I've had some serious problems with my family. I can still sell my art, occasionally, because I have the internet, and I have

[1] Committee for Open Debate on the Holocaust, www.codoh.com.

a bit of a reputation behind me. I have a website, and people can go to my website, and I can sell it off the website. But the family situation, I didn't realize I was going to get this kind of treatment from the people that I grew up with. It's really a sad thing. I used to be invited to Thanksgivings at my brother's house. Thanksgiving in America is a big holiday. No more Thanksgivings over at my brother's.

Going to prison is one thing, but getting a freeze-out from your family is almost worse than having to serve a sentence in prison. I wish that more of us could be more courageous about our beliefs, but I do understand what's at risk here. I've come up against it, and I'm here to tell you, it's hurtful. I just wish that people had broader minds, or more time to get the information that they need, so that they would understand why we are the way we are.

As a group, we know more than everybody else. I mean, Ursula Haverbeck probably knew more about everything than anyone in that courtroom that she went into. The judge, her lawyers, the press outside. She's a walking library of information, and everybody else there are midgets, and they're the ones that have convicted her.

Arthur Topham is a journalist/prospector that lives above me in British Columbia. I live in Washington State. Arthur's up there. Friday [November 26, 2015], he just got convicted of insulting Jews on his website. Gilad Atzmon flew from here to testify for him in, it's a logging community, I think it's called Quesnel, up in British Columbia. I think Arthur is married to an Indian woman, by the way. He was a newspaperman, and then he has a website, and he's involved in exposing Jewish perfidy and commenting on current events. Well, they convicted him. He's going to jail. It was announced Friday. So, he's another one. Ursula and Arthur, both last week, are on their way to prison. He ran something called the Radical Press. He's a Canadian free speech activist who has been treated very, very shabbily.

As far as art, I want to say one thing. As an artist involved in the arts community and working with dealers and museums and collectors, there is no free speech. There is a program. The arts are managed by bureaucracies, which are part of city, state, and national governments. As artists, we go to these bureaucracies for funding. Then there are private philanthropy groups. They provide some of the funding too. So when you're an artist, you are competing for funds. You're competing for commissions from your community. If you get beyond the community to the national level, you're competing again nationally for commissions and grants and stipends. Above that, there's international.

Well, all the way from the community to the international, it is completely cultural Marxist. By cultural Marxism, I mean they are promoting multi-culturalism. They are promoting equality of the races and the genders. You can't hope for any kind of help from these people if you take on the Holocaust, or if you take on multi-culturalism, from the wrong side. Just forget about it. And they don't like irony, that's the thing. I was slipping it by them with this postmodern, ironical commentary on everything that interested me. That's the way I could keep them off my back. "Oh, I'm being ironic, you know." I was being ironic! This is kind of goofy. It's irony. But, at the same time, I think that Nick Griffin is an okay guy. I've seen him get up in front of the EU and chew them out, and God bless him for it.

As a white, male, heterosexual, American artist, if I want to get ahead, I have to abase myself, come up with some sort of way to punish myself for my grandfather's "crimes." This is ridiculous. Why am I being held to this whole business about American imperialism? It's not me. As an artist, I have to pretend that I'm guilty. That's what we have to do. The art that they want you to make is about "white guilt." And "white privilege." You are to comment on it and say, "Oh, this is terrible, bad!"

It's the law there, in my profession. The people that sit

behind the desks, that present all this, and when you go to the museums, they're the directors, and the curators, they are all on this same train going to a monoculture that doesn't have any room anymore for any kind of real self-expression. Then this business about we don't want to hurt anybody's feelings. You can't make hurty art. It's hurty! It's hurting someone, so don't make it. I'm so sorry your feelings were hurt, gee!

Back to the Holocaust. I got this idea, and I'm going to explore it here. I've been watching the Holocaust revisionist movement since I discovered it, and that was in the 1990s. More people, yes, they are finding out about it, because of Facebook, websites, podcasts, and a few meetings like these. These meetings are small, by the way. I attend them in the United States. They're no bigger than this. This isn't big. So, there's not very many of us in real-time, but there's plenty of us on the internet. Kids are getting all hopped up about the Holocaust and what a fable it is. Every day, people pick up the thing, and they repost it and share it. But I'll tell you what. It's all about the forensic investigations of the Holocaust that were done in the 1980s with Ernst Zündel and his team of revisionists in Toronto. And it's stopped there. It hasn't gone any further!

Holocaust revisionism went from obscure books and periodicals that you had to send away for to obscure places, to the internet where you can click on it. Then it went into YouTube videos, where it's explained to you in a video. Because everybody's getting too lazy to read. So this next generation coming up behind ours, they don't read. They don't have time to read. They have been brainwashed with fast-paced bursts of information. So if you want to get the message across to them, you've got to present it the way they get it off the television.

I'm seeing the recycled information from the Zündel trials—there were two of them—over and over and over again on the internet. Nobody, but nobody, is talking about the

Holocaust as a psychological warfare operation that was plotted by psychological warfare soldiers in London during World War II. They had departments. I've been to Kew Gardens. Sir Bruce Lockhart, C. D. Jackson: these are American and British psychological warfare, black ops departments, cooking this stuff up using the Polish government in exile—and Jewish charities, mind you—and the OSS in Switzerland. All to float this fable. It's war surplus. It's left in place. It's like a rusty old tank that they forgot to break down and recycle.

I would like to be put in touch with anybody in the room, or anyone who knows somebody, that is looking at the Holocaust from the perspective of psychological warfare and the people involved. Because I never see the names of these people. I've heard about Sefton Delmer. I don't think he was involved in this.

Hollywood! The U.S. Department of Psychological Warfare sent these directors to Europe, into the camps during the liberation, and they helped create the fable with creative film editing. It's very, very interesting if you pick yourself up, out of the camps and all of the nit-picking that goes on with the forensic argument, which has really been settled. We know that.

Look at it as brainwashing and how the media has delivered this message to us and how it was constructed by the media, with the help of these intellectuals who knew about the human mind. They were brought into the war effort. They're psychologists and psychiatrists and Eastern European intellectuals like the Frankfurt School, for example.

Franz Neumann was working with Wild Bill Donovan at the East European desk of the OSS, which was our secret service. This man is a Marxist who was kicked out of Germany for spreading communism. His whole New School for Social Research: we just brought them to America! We put them in our universities. We gave them plum jobs in our universities to spread their poison.

Another thing that a lot of people don't know about is the Ritchie Boys. We had a camp in the United States, in Maryland. There were 9,000 German-speaking, mostly Jewish, psychological warfare soldiers trained there and then sent to Germany after VE Day as interrogators, lawyers, disinformation agents, and hangmen. These people were up to all kinds of crazy social engineering tricks to de-Nazify Germany.

Then they put the ones that worked to work on us after the war, in advertising. Those guys went into the RAND Corporation, and they went to work for people that will hire think tanks to figure out how to sell a new brand of Coca-Cola.

It's been honed since World War II, this psychological warfare. That's all you can call it. It was turned on the Germans, and after the war it was turned on the citizens of the United States and the Allied countries. That's how they get us to go along with all these hare-brained ideas that they have for this one-world government, with a one-world army, and a one-world court, and a one-world culture, and a one-world prison. A one-world religion!

Psychological warfare: I want to know more about it, and I want to communicate with people who are as interested in that particular subject as I am. Because it needs to be mined. I think that might be the next way that we can dismantle the fable.

That's about all I've got to say.

Jez Turner: He's a white male, heterosexual, American artist! He's not brainwashed! He's a heretic! He's a man who cares about the survival of his race! He's a brave man! He's Not Banksy; he's better! He's Charles Krafft!

What's Wrong with the Arts?

November 12, 2016

This is Charles Krafft's talk at the inaugural meeting of The Northwest Forum in Seattle in the heady, happy days after Donald Trump's election. I would like to thank K.C. for this transcript.

I want to start by telling you all that you can interrupt me at any moment and ask a question, and possibly we could have a small conversation. I haven't really given my subject matter much thought, but what is wrong with the arts? I have some stories that I can tell you that encapsulate what I think the situation is out there.

I'll begin by telling you that someone I know has been working with the Seattle Arts Council on getting funding for a circus performance with some trapeze artists. There's a granting cycle that the city provides for artists, performers, and literary people in town—and you find out by going to these arts organizations when the funding cycles begin and end—what you need to prepare for asking the city, the state, or the federal government for money.

And as artists, a lot of us at a certain level have to learn how to go through the funding application process in order to get subsidized, because it's a difficult thing to make your way in this society unless you're a celebrity artist, and celebrity artists are, I think, maybe 0.1% or maybe even less of people claiming to be artists. I mean, you hear about Andy Warhol, but this man is in a level of celebrityhood that is so far beyond a working artist that it's unimaginable, you see.

Most of us are obliged to go to our city, our state, or the federal government for funding. It's very difficult to make it with sales, because people are making the stuff, they're making conceptual art, and what do you do with this? Like this woman Marina Abramović going into a museum in NYC and painting words on the wall with cow's blood. I mean, somebody's got to pay for all that: they've got to pay for her to come in; they've got to pay to clean it up. The whole business is a substantial investment for the Guggenheim or wherever she did her spirit cooking performances. She's getting some funding probably from private patronage, and then she's also probably getting it from the city and the state of New York.

My friend wanted four thousand bucks to help this company of trapeze performers put on a show in Seattle. So, she went down there and talked to the funding agent, and he said you have to tool their performance to minorities. Well, for her to get the money, she's got to think about the Sikhs, the Somalis, the Eritreans. She's got to think about the Nigerians, and she's got to think about everybody except the people that the theme of the show was about, which was a cult of hippies that disappeared after the sixties and then re-emerged in 2001 and decided to relaunch their career as middle-aged former hippie stars. This is all for trapeze artists—but that's the story. These are just white hippie girls that disappeared and came back—kind of like Dolly Parton and Emmylou Harris if they were trapeze artists [laughs].

So, the problem with the situation across America is this multicultural mandate that you have to have to, number one, exhibit your work if you're a visual artist at a gallery, perform your art on stage if you're a theatrical person, and then if you want to be a poet or a novelist and you need an extra bunch of money to complete a literary project or build a website or do whatever they're doing out there that they call making culture. You have to toe this party line which is cultural Marxist. And that is a big problem out there with

people in the profession.

But I'll tell you what, there are so few of these culture-makers in America that are thinking along the lines that we do, that I don't see any kind of a crack in this wall that I watched happen. I remember in 1995 that I was working with the Center on Contemporary Art (CoCA) in Seattle, and, all of a sudden, for us to get this grant for this non-profit arts organization that we ran here, we had to start making exhibitions for minorities—for women, homosexuals, and racial minorities.

In order to qualify for that annual $10,000 grant that we counted on every year (one fourth of our budget), we had to prove that we were going to bring in these other people to make sure that they get a fair shake and representation in the arts in Seattle. We started engineering shows that had to do with—oh, we're going to have the gay show in September, we're going to have the women's show, and that will be in August, and then we'll have the Native American show in another month, then we'll have a show for artists [laughs]. I mean, it all got compartmentalized into these various kinds of communities—and art is art.

It really shouldn't make any difference if you are male or female, gay or straight, if you're a Native American or a Negro. It should be recognized as art by, I guess, art experts that don't have all this baggage attached to it.

If you've noticed, there's all this baggage attached to the arts in America now. These grants that are being given, the attention people get in magazines, that has to do with their sexuality, their gender, and their race. And the old white guy like myself that's sort of on the outside of the whole scene now, whereas, it was just taken for granted when I was becoming an artist, we weren't thinking, "Well, I'm a white guy, and I'm on top of the heap." It was just, "I like to make art."

It just happened in those days that most of the artists that were professional were men. We had a show at this

CoCA place, and it was about hot rods. And we were bringing this collection of artifacts from hot rod culture in southern California to Seattle, and it was going to be presented at our space. One of our board members, who was female, said, "Well listen, there's no women in this show. What are we going to do about that?" I said, "Well, there aren't any women pinstriping hot rods in 1947" [laughter]. And she said, "Well, okay, but can't we bring some women in here? Because we've got to have women, or we're not going to get any money from the government unless we have X number of women in our exhibition." So, we went out and we found somebody who did some kind of low-brow cartoon monster art, a female; we brought her in.

Then there was a big problem with the poster that we did. On the backside, it had a gearshift knob that was a shrunken head that they used to sell to car guys back in the fifties, you know, with those strings coming out of their mouths and the long hair, and you put it on your gearshift knob. The same girl that was concerned about the lack of females in this exhibition told us, "Well, these are racist artifacts," and I said, "Well, they don't even make these anymore!" We lifted a page from an old custom car magazine and put it into our poster because it reflected the era that we were trying to celebrate or educate. That's the deal.

And oh, I want to tell you, too, Pepe was invented here in Seattle. The guy's name is Matt Furie, and the Alt Right stole Pepe from Matt Furie. Matt Furie is represented by a comic book company in Seattle called Fantagraphics. So, Matt Furie and Gary Groth, the head of the publishing company, went to the ADL and started whining like big babies [laughing] because Pepe got stolen from them. And they're just fit to be tied. They're going "Oh my God, Pepe is a Nazi Frog," and "Look what they've done to our Pepe." And that was publicized on the internet, and then it was publicized in this—we have a Left-leaning cultural Marxist free news-

paper in Seattle that is so typical of the attitude of the Pacific Northwest—as far as the culture here. They were concerned about the Alt Right taking Pepe away from Matt Furie and Fantagraphics. And then to drag the ADL into this thing—it just made me sick.

The Frankfurt School were the people that were brought from Germany into the United States. They were precision placed in the academies and universities by the foundations in America—Ford, Carnegie, Mellon, you know these people who have mass amounts of money. You can read about the Frankfurt School. You can read Adorno; you can read the others. And the idea was to make art and culture so unharmonious and ugly that it would destroy the culture that preceded it, because these guys were Marxists, and Marxism cannot live alongside any other "isms," you know; it's the precursor to communism. So, you get into a culture, you start spreading your little Marxist ideas.

These guys are theoreticians from Frankfurt, Germany that concocted this theory based on Antonio Gramsci, because they couldn't take over Europe by force of arms. They had to come up with another idea, and the idea was "Well, we'll go in on the long march through the institutions." Institutions are, of course, the universities, the art museums. And these guys had this plan, and the plan was to make all this hideous art and atonal music from a donor. Where do these guys get their ideas?

It's resulted in a popular culture, which is at the very top, supposed to be intellectual, enlightened, and elitist. You end up with a Marina Abramović painting museum walls with cow's blood and everybody clapping and thinking there's something profound to this—something extremely occult and witchy, and wonderful, and edgy, and transgressive. It doesn't amount to anything.

The Dadaists, when they had their moment, had the honesty to admit that what they were doing meant absolutely nothing. We're Dadaists! Dada means hobby horse.

We do nothing. We're just making a statement that has been interpreted, if you would like, as anti-war—which is a term that came up out of the slaughter of the First World War. They said all this stuff that we're throwing together really amounts to nothing but a protest against cultures that lead their men into the battlefield as cannon fodder, and we don't want to go, and we don't want to die—and that was Dada. And they had the honesty to say Dada means nothing.

After Dada, you get these other movements, and you get the intellectuals that come along with promoting the movement, and now we've got an art press, art festivals—that's the Top of the Pops when you're an artist, if you can be invited to an International Arts Festival. You get out of school, then you get a gallery, maybe—if you're lucky, and then if you do good in the gallery, you possibly get invited to an art fair in a city. If you're noticed at an art fair in a city, then you get invited to an art festival in Europe or South America, or in Cuba—these biennales. And that's all locked up too with this cultural Marxist mandate which is egalitarianism, strange kinds of ugly painting and actions and words and protests about the standard stuff about the oppression of the minorities, colonialism, and if you're from Africa, you need to make a statement about how woebegone your society is, they'll give you a whole pavilion, and you can just go ahead and whine away.

And it starts at the city level, it goes to the state level, it proceeds to the federal level, and to the international level. And at the very top of the pyramid is the international level that's a very small cabal, clique of curators and critics who anoint an artist who then becomes a kind of international celebrity, and they get re-invited year after year to these places. Their name lends some kind of cachet to this biennale.

Let's say in Brazil, if you can get a Marina Abramović to come to Brazil and do one of her spirit cooking gigs, then

that makes you look like you're very cultural-enlightened, and it's kind of like advertising your country as being a member of this global society that is becoming homogeneous wherever you go.

If you guys get on airplanes, and you take off in every direction, for every human being in this room, when you land you will find the same culture there. And it's really sad because the airports look alike, the museums are starting to look alike, the food is getting corporatized, and there's a Starbucks in every—like in Paris you go to your Starbucks or in downtown Rome, Italy—pop into a Starbucks. That's all the same. You look at the art—modern art I'm saying—that is the same. I could go anywhere and find the same dozen artists with the great big paintings in that country.

All those Pop guys, and before the Pop guys, you've got the Abstract Expressionists who are American and then the European—the British—Damien Hirst and all that. I'm supposed to go in and look at the stupid Damien Hirst spot painting, and I'm supposed to be overawed because it's expensive—somebody paid a lot of money for it. That's all it's about. Damien Hirst's painting must've cost a million five hundred dollars, and then you look at it. It's spots, right? Just a bunch of multicolored dots, right? Okay, wow! And you think that because someone paid that much money for it, it's good. But not necessarily. So, I've discovered that there's that world of elitism and intellectual masturbation that goes along with what you call the fine arts.

And then there's the hobby crafts. And I've drifted from the fine arts into the hobby crafts when I wanted to learn what I wanted to do on china, you know, paint blue flowers on a teacup and make it stay there. And the hobby crafts are what you find at the county fair. You go to a county fair—and I was there at the Puyallup Fair three weeks ago—and I loved going to the damned fair because I like to see what the people that don't have to worry about art, what they do with their hands. And these little ladies are sitting

around painting, oh God, you know birdhouses—little blue wooden birdhouses. They've got their paintbrushes, and they're painting these designs on the birdhouses. They're doing tole painting. I don't know if you know what that is. There are these pattern paintings that came out of Germany and Scandinavia that are very scrolly.

I'm fascinated by the ease with which these people that don't consider themselves artists can make these objects that are not considered art. They're considered hobbies. There are skills that they teach each other, and there used to be more of them before television. That really killed the crafts in America, and probably everywhere else, because people spent too much time in front of TV and less time in the workshop or less time in the sewing room making things with their hands.

So, the hobby crafts—I got mass amounts of inspiration from people that don't consider themselves artists, and when you tell them—you see, I joined a ladies' china painting class so I could learn how to paint on a plate. And these ladies, they thought "Boy, we have an artist with us!" and then they brought me extra sandwiches at our meeting, because they thought I was a starving artist—"Oh, a starving artist!"—and "Bring him an extra sandwich."

And at the Puyallup Fair, I go and I talk to them, because I'm interested in what they are doing and thinking, and I also like to pull their chain, too. I like to get up right in their faces and make comments about what they're doing. But they always say, "I'm not an artist. I'm not an artist." And I want to tell them that you're a better artist than half the people I know who call themselves artists, and you shouldn't feel like that just because you don't have a machine behind you that creates a celebrity artist. You can't tell them that because it's a different world—but I would like to tell them that.

So, we've got the Frankfurt School in the critical period ruining everything for everybody as far as making beautiful

objects go. It all has to be some kind of revolutionary avant-garde transgressive what-are-we-going to-do-next to *épater la bourgeoisie*—which means to shock the bourgeoisie. Every year, it's got to have more shock value, and every year it gets more and more silly, because that's what they think they need to draw attention to themselves for a career in art—the shock value—and then beauty gets set aside.

And nobody even talks about beauty anymore, and that is, I believe, what art should have: some element of beauty in it. I like the idea of craftsmanship, too, because when you look at something and you can see that somebody has spent some time thinking about it and then some extra time making it, instead of just tossing it off and putting it there, trying to convince you that graffiti is art. It's not art, man! I don't know who these guys think they are. It's just hideous! Pull in a train to any major city in the world, and there you've got all this scribbling all over everything—and they encourage this.

I was in Slovenia; I went to Ljubljana, Slovenia one year, came home, and went back the next year, and the whole place was covered in this crappy, spray-painted tagging. I said, "What's going on here?" and they said, "Well, they think this is self-expression." They're telling the kids it's okay, and it's not okay, because it's ruining the architecture underneath it. It just makes the society look chaotic, and I don't know, maybe you like graffiti, but I don't even like it when they can do it right [laughs].

I've seen the great big sprays, you know, the Mexican Aztecs with feathers, and babes, and all that stuff. And it's always got to be about that community, too, a great big wall mural. Everybody is from somewhere in the world, and they're all having fun together, and it's just a bunch of bullshit—hahaha! So, if you're trying to get us to believe that through the arts that the immigrants are assimilating—they're not! [Laughs] We're not holding hands; we're not having fun doing the same things. We might be living in

the same city, but we're all in our own little areas, and we all have our own sets of friends.

Diversity is being completely socially engineered at the top, and there's a book, if you guys are interested in what happened, called *The Cultural Cold War* by Frances Stonor Saunders.[1] And this was a CIA operation to make American Abstract Expressionism the cultural export, and then to promote Americanism everywhere, which is part and parcel of us colonizing the rest of the world with our ridiculously low-brow culture. American Mickey Mouse, you see, that's everywhere. These movies that we're making—the X-Men and Batman movies are drawing mass audiences in China. That's why they make this crap, because they're exporting American culture, and they got the rest of the world to think that we had this interesting culture.

The CIA is made up of intellectuals, believe it or not. The CIA is not cloak and dagger so much as social engineering. And their scientists understand mass communications and the systems that get people to believe things, and then they proceed to be hired—like Edward Bernays and William Burroughs' uncle, Ivy Lee—to go out and convince people that they need stuff that they don't need, or the stuff that they're looking at in museums is profound, when in fact, it is not profound.

That happened with the help of what we call the "Culturebergs." There were three Jewish art critics in the '50s that helped launch Abstract Expressionism, as well as the CIA who put it in all the embassies around the world. Had these shows going around, they had intellectuals following it, you can read all about it. But Greenberg, Rosenberg, and Steinberg—that's the Culturebergs. And I have to tell you that what we got here is very Jewish, and the money that

[1] Frances Stonor Saunders *The Cultural Cold War: The CIA and the World of Arts and Letters* (New York: The New Press, 2000).

buys the art is Jewish, the artists that make the art—a lot of those celebrities, including Marina Abramović. That's one of the reasons she is where she is—she's half-Jewish. She's a Serb. There's that business.

This is all kind of intellectual stuff. You could find out a lot about it at the *Occidental Observer*, and if you want to pursue it, it's kind of what happened to America and what happened internationally. The Saatchis, these collectors, these guys have so much money they don't know what to do with it, so they decide they're going to buy an artist, and once they get picked up by one of these oligarchs—or not necessarily even an oligarch—but just a highfalutin businessman with extra money to spend on art, and all of a sudden you're anointed as being collectible, and then the next guy wants some of you, and then the next guy wants some of you, and pretty soon, you've got a book about yourself and then another book about yourself, and it goes on and on and on.

But I would like to maybe ask you to ask me something.

[Inaudible question/comment]

... you mean to go ahead and mock them? Yeah, I think that would really help to make them look ridiculous, because that's exactly what they are. The only problem is that—can you get the rest of the normies to get the joke? They're so damned stupid that they wouldn't even see it.

I have this one guy that bought two Amy Winehouse teapots because he likes Amy Winehouse, and then I went into his store and he told me that he was getting phone calls from customers telling him that they didn't like the idea. He said "I had to take your art out of the window because I was getting telephone calls about you. Is it true that you don't believe in the Holocaust?" I said, "Yeah, I'm afraid so" [laughs]. And he was shocked, and aw man, it was sad, he was crestfallen about what he'd heard from these people that were calling him up to ask him to remove the Amy Winehouse from his store window if it was true. "I just

thought this was something that they made up just to smear you," and I said, "Absolutely not! I'm a Holocaust denier, sir!"

Let me tell you about that Amy Winehouse. I didn't want her in with the rest of the good dictators [laughing]. I was collaborating with this guy named Mike Leavitt on those. He said, "We got to do Amy Winehouse" and I said, "What for?" and he said, "Well, I just like her face and that beehive hairdo"—but, it turned out to be okay to do.

She is a wreck, you know, and so is Miley Cyrus, and some of these other people they've asked us to—well, they put them forward to get the kids to emulate their behavior. And this whole heroin chic with Kurt Cobain you see, and before then, William Burroughs, all of a sudden everybody is taking heroin because their stars are addicted to it, kind of promoting it through the attention that they get for taking it, you see. I'm kind of a conspiracy theorist. I think that might have been engineered, too, heroin chic, because I'm convinced that psychedelics were unleashed on my generation as a biological warfare weapon. LSD was developed as that, and it comes into my culture and deracinates all of us, and then the next thing is everybody is overdosing on heroin—that's ten years later.

I've been tuning in to gnosticmedia.com,[2] and these guys, they got the paper trail on Aldous Huxley, Tim Leary, Ken Kesey, the Merry Pranksters, Terence McKenna—all these guys that we think are visionaries. They're just set up to look like visionaries because they've got an agenda that they're promoting, and their agenda was to get the kids in the '60s to quit protesting the Vietnam War because they had so much money invested in the military-industrial complex and then to start navel-gazing. So, they passed out the LSD, and they told them this was a way to a spiritual experience that you're having, and Tim Leary and these

[2] https://logosmedia.com

other guys said "Yeah, and oh well, this is the quickest way to God." And so, that's why I did it [laughs]. It was, hey man, listen.

In order to be a CIA agent, you have to take the Leary examination. It's a personality test that they still have, and they give the guy, the potential agent, or asset—or employee because not everybody—like I say, the CIA is about social engineering, really. A lot about it! Leary was CIA, and he even said as much. Jan Irvin, they've got a movie of all those guys that were involved in MKULTRA having a party at the end of the '60s, patting each other on the back for how they got this idea spread out to the culture. Each week, I go back to tune in to see how much more evidence they've unearthed. It's real fun. I bought it—hook, line, and sinker. I swear to you, I was the biggest hippie on the planet [laughs].

[Inaudible question/comment]

Oh, that's a good question. Hey listen, if I'm an example of pearl white art, I think you'd better hold off on that a while, because you're going to get chastised. In the all-inclusiveness of this diversity that they've promoted, there's no room for whites just yet. We might have to go back in as a white artist.

I was always interested in zine culture. I got involved in subscribing to, before the internet, to zines. They were little self-published magazines that people sent to other people that were interested in the subjects that they were. And I was interested in—I was always interested in music—neofolk music. So, along with the neofolk music came a bunch of iconographies that looked Third Reich-ish, and I was curious about that, and I discovered Laibach.

And I got involved with Laibach in Slovenia through a granting foundation in NYC. They sent me to work with Laibach. I went to Sarajevo with them during the war and immersed myself in what they call Retroavantgardism, which was their cultural Marxist theory about what they

were doing. I don't want to get into that, but I realized they're from a Marxist society, they had a post-socialist nostalgia for how they grew up, which was different than us, and so I thought, well, these guys are really smart because Slavoj Žižek was their philosopher for Neue Slowenische Kunst. It's a collective, and Laibach's the musical arm of it.

But I didn't get red-pilled until I went to Romania and started looking into the Iron Guard. And these guys were Christians, and they were prepared to lay their lives down to not lose their culture because at their universities in the 1920s—1927—Marxism was leaking into the university and they realized . . . I think it's called autochthony, when a society identifies with its religion. Is that right? Indigenous culture, correct? That's what the Iron Guardists were wanting to preserve, because they saw the Russian Revolution and what had happened nearby, and that kind of fervor, the revolutionary fervor was spreading through Europe, and that's why Hitler decided they had to stop it in Germany—but Romania got a taste of it, and that's how I got red-pilled.

I'm interested in history, and I was interested in this Slovenian avant-garde art group that had a music arm, and then I got interested in Romania. Then I got really interested in the Iron Guard, because they were prepared to die for something. I can't think of anything I'm prepared to lay my life down for. What kind of world must it have been where a man would go and sacrifice his life for something he believed? And so that's what happened there.

[Inaudible question/comment]

If you could get enough Alt Right guys doing the handmade movement . . . I was approached by one of the ladies that popularized that and made a movie about it, and a book, and so I know what's going on. The hobby crafts in that particular milieu are open for hijacking. You see, that's what I did with Delft painting. I hijacked the whole thing. I turned it upside-down. The idea when I started was that you have these prosaic pictures of roaming cows

and windmills on plates, but I started painting air disasters. So, all these arts—quilt making and whatever you have—you guys must have those shows around Christmas time for handmade stuff. Do you have the Makers Exhibitions? Sure, you could go in there and have a whole bunch of fun, but if you do something a little bit . . . Right now, you're going to have to slip it by them somehow. You're going to have to outsmart them, because they're not going to be prepared to accept something like a swastika or anything—not that you need to put one on.

[Inaudible question/comment]

What about the t-shirt the kids wear, with a red star or anything with a red star on it—or a picture of Che Guevara—and that's all *de rigueur*? Nobody is going to make any bones about that, but try a Right-leaning dictator or figure from the past that was not a communist or an anti-communist—it doesn't have to be Hitler every time; there's lots of other people. And that's another thing that I like about learning.

Listen, there were a bunch of artists and writers who were on the Right side of the political spectrum, but ended up on the wrong side of history. You've got to go back and find out how many of those types there really were, because after '45, they cleared the decks on this. It's just been cultural Marxism from VE Day—I say every day since VE Day has been a Marxist holiday for the culture-makers of the West. That was it! You know everybody—blip, you're over there, down the memory hole. You've got to kind of dig for those guys.

INDEX

A
Abramović, Marina, 147, 150, 151, 156
Abstract Expressionists, 152, 155
Ahmadinejad, Mahmoud, viii, 59, 60
Akhenaten, 32
Alfassa, Mirra, aka The Mother, 35
Alinsky, Saul, 67
Allen, Paul, 2
Alt Right, the, 149–50, 159
Anderson, Guy, iv, v, 6–7
Anderson, Kirsten, 31, 39
Anderson, Kurt, 101
Andrea Doria, sinking of, vi
Answer Me, 114–15
Anti-Defamation League, (ADL), 68, 149–50
antifa, 57, 94, 105
anti-Semitism, 56, 64, 81, 87, 122, 130–31
Antiwar.com, 83
Antonescu, Marshal Ion, 14
Apocalypse Culture, 119–20
Archeofuturism, 48
Army Signal Corps (USASC), 51
Art Deco, 26
Art in America, 115
Artists of the Right, xix, 41
Artists Rifles, 136
ArtsLink Citizens Exchange Council [now CECArtsLink], 10, 58
Aryan Nations Church, 54
Asia, v, 6, 18, 88
Atlanta, 32
Atzmon Gilad, 141
Australia, vi, 29
autochthony, 13, 159
axis of evil, 59
Aztecs, 154

B
Baha'i Faith, 6
Ballet Russe, 37
Barnes, Harry Elmer, 78
Bartlett, Scott, 3
Batman, 155
Bay Area, the iii, 2, 4
Beatles, The, v, 96
Beatniks, iii, 2, 4, 17
beauty, 22, 154
Belgian Conceptualists, 15–16, 24
Belgian Impressionists, 24
Belgium, 15, 24
Benson, Michael, 11
Bernays, Edward, 155
Besser, Sandy, 63
Bhagavan Das, 17
biennale festivals, 151
Big Sur (Kerouac), 4
Bill of Rights, the, 79
Black Sabbath, 15
Blanchard, Jim, 96
Blavatsky, Helena, 59
Blondie (rock group), 30
Blood Axis, 15
Blum, Howard, 61

Boeing, iii, 1
Bolshoi Ballet, 103
Bolton, Kerry, xx, 20, 41–43
bone china, viii, 8, 135–36
Book of Revelation, 6
Bouquet, Hyacinth, xvi, 45, 47, 85, 98, 129
Bowden, Jonathan, 45
Braque, Georges, 23
Brautigan, Richard, 4
Brazil, 151
Breker, Arno, 19
British National Archives, 51
Bucharest, x–xi, 13–15, 138, 139
Budapest, xiv, xvi
Buffet, Bernard, 96
Burroughs, William, 155, 157
Bush, George W., 59
Butler, Richard, 54
Buttercup Dew, xvi, 129

C

California, vi, 4, 5, 45, 149. See also Bay Area, the
Callahan, Kenneth, v, 6–7
Carnegie Foundation, 150
Castañeda, Carlos, 17
Catholicism, 10, 58, 60
CBS, 51
Ceaușescu, Nicolae, 14
Center on Contemporary Art (CoCA), vi, 8–9, 96, 148–49
Ceremonial (album), 96
Chandler, Raymond, 96
Chia Pets, 60
Chihuly, Dale, 8
Chomsky, Noam, xx, 43, 116
Christian College Student's League, 138
CIA, the, 155, 158
Citizens' Exchange Council; see ArtsLink Citizens Exchange Council
Civil War (American), the, 75
Cobain, Kurt, 157
Cockburn, Alexander, 83
CODOH (Committee for Open Debate on the Holocaust), 139
Codreanu, Cătălin, x, 13–14, 137–38
Codreanu, Corneliu, x, 13–14, 137
Cole, David, 120
collective guilt, 75–76
Communism, vii, 12, 14, 58, 60, 144, 150, 160
concentration camps, 51, 73, 139
conceptual art, 15, 147
Confederate General from Big Sur, 4
Copro Nasen Gallery, 30
Counter-Currents Publishing, Ltd., xi, 19, 41, 80, 82, 102, 114, 118–19, 133
Counter-Currents Radio, xi, xv, 52, 93, 98, 125
Counter-Currents retreats, xi, xv, 45, 85
CounterPunch, 83
Country Joe and the Fish, 3
Covington, Harold, 93
craftsmanship, 22–23, 154
Crowley, Aleister, v, viii, xviii–xix
Crumb, Robert, 96

Cubism, 23
Cultural Cold War, The, 155
cultural Marxism, 49, 86, 89, 92, 106, 123, 142, 147, 149, 151, 158
Culture of Critique, The, 94
custom car culture, vi, 5, 149
Cyrus, Miley, 157

D
D'Annunzio, Gabriele, 19
Dachau (concentration camp), 139
Dada, 20, 150–51,
Dalí, Salvador, 19, 50
Daniélou, Alain, 37
Dayton Accords, vii, 135
de Zurbarán, Francisco, xix
Death Teams, 137
Deckert, Günter, 76
Defense Ministry headquarters of the Republic of Slovenia in Ljubljana, 8
Delftware, vi, 7, 29, 52–53, 56, 130, 135, 159
Delmer, Sefton, 144
Delvoye, Wim, 15, 16
denazification, 144–45
Denson, Ed, 3
Department of Psychological Warfare (US), 144
Department of Pure and Applied Philosophy, 11, 38–39
Devo, 30
DeYoung Museum, 63
Disasterware, vi–vii, 7, 29, 52. *See also* Porcelain War Museum

Disney World, xx
Disneyland, 97
Dispossessed Majority, The, 62
Donovan, William "Wild Bill," 144
Douglas, Kirk, 95
Dresden, bombing of, vi, 133–34

E
Each Time You Carry Me This Way, 96
East Germany, 54, 65. *See also* Dresden
Eastern Europe, x, 13, 23, 58, 60, 137
eBay, 66
Eberhardt, Isabelle, 97
Eliade, Mircea, 118
Esquivel, 119
European Union, 79, 142
Evola, Julius, 20
existentialism, 22
Exotica (music genre), 120
Extra Finger, The, 71

F
Fabre, Jan, 15
Facebook, 43, 48, 56, 70, 72–73, 86–87, 99, 117, 131, 143
Fantagraphics, 149–50
Fascism, vii, ix, 9, 26, 58, 85, 115
Faye, Guillaume, 48
Feral House Publishing, ix, 32, 81, 120
First Amendment, the, 76, 78–79, 108, 123

Fisherman's Wharf, 4
Fishtown, iv–v
Flickr, 25
Florence and the Machine, 96
Ford Foundation, the, 150
Foreign Policy Journal, 42
Fortune, 51
France, 22, 35, 75, 106, 111
Frankfurt School, 144, 150, 153–54
French empire, 75
Frye Museum, 27, 28
Furie, Matt, 149–50
Futurism, 26, 46, 114. *See also* National Futurism

G

Gandhi, Mohandas, 36
Gates, Bill, 2
Gayssot Law, 106
Gaza Strip (film), 96
Gestalten Verlag, 29
Ginsberg, Allen, 4
Gnosticmedia.com, 157
Goad, Jim, 96, 114–15
Goebbels, Dr. Joseph, 26
Goldhagen, Daniel, 73
Google, 25–26, 109, 118, 133
graffiti, 133, 154
Graham, Alex, xvi
Gramsci, Antonio, 106, 150
Graves, Jen, xii, xiv, 61, 67, 69, 70, 81, 86, 96, 102–103, 117
Graves, Morris, iv–v, 6–8, 15, 96
Great Society, The (rock band), 3
Greenberg, Clement, 155

Greitz, Paul, 54
Griffin, Nick, viii, 130, 142
Guardian, The, 89, 132
Guénon, René, 20
Guevara, Che, 160
Guggenheim Museum, 147

H

H. P. Lovecraft Prize, the, xi, xii, xvi
Hamsun, Knut, 19
handshakes, 126–28
Harris, Emmylou, 147
Haverbeck, Ursula, 140, 141
Heidegger, Martin, xx, 82
Henderson, Barbara, iv, vi
Hey! (French magazine), 106
Hi-Fructose (magazine), 115, 118
Hindenburg, explosion of, vi
Hinduism, v, 100, 132. *See also* India
Hirn, Miriam, v, 33–35
Hirst, Damien, 152
Hitchcock, Alfred, 51
Hitler and the Power of Aesthetics, 26
Hitler, Adolf, viii, 26, 32–33, 40–41, 54–56, 60, 63–65, 91, 159–60
Hitler's Willing Executioners, 73
hobby arts or crafts, iv, 7, 40, 53, 152–53, 159
Holland, 52–53. *See also* Delftware
Hollywood, iv, 30, 121, 144
Holocaust, the, 51, 68, 74, 79–80, 95, 99, 143–44.

See also Holocaust revisionism
Holocaust Historiography Project, 11, 71
Holocaust industry, 74
Holocaust revisionism, x, 48, 51, 58, 61, 64, 67, 70–74, 76–78, 84, 85, 87–89, 91, 98, 101, 106–107, 131–34, 136, 138–40, 143
Holocaust, as a psyop,
Hoover, Herbert, 84
Horus the Avenger, 113
hot rods, iv, vi, 4, 149
Howard, Kenneth. *See* Von Dutch
Howard-Hobson, Juleigh, xvii
Huffington Post, xii, 89, 102–103, 132
Huxley, Aldous, 157

I
Iceland, 19
iconography, 58, 63, 82; see also symbols & symbolism
Immigration and Naturalization Services (US), 139
Impressionism, 24
India, v, 16–17, 34–37, 53, 63, 88, 100, 132
Insane Clown Posse, 56
Institute for Historical Review, 139
Interrogation Machine: Laibach and NSK, 11
Ionesco, Tudor, 13, 14
Iron Guard (Romanian), the, xi–xii, 14, 136–37, 159
irony, 65, 142
Irvin, Jan, 158
Irving, David, 94, 139–40
IRWIN, 11, 23
Israel, 79, 82
Italy, 26, 29, 139, 152

J
Jackson, C. D, 51, 143
Jai Uttal, 17
Jewish Daily Forward, 67
Jim Crow, 75
Johnson, Greg, xx–xxi, 87, 90, 93
Jünger, Ernst, 115
Juxtapoz, 115

K
Kaczynski, Ted, viii
Kali Yuga, 33
Kalki, 33, 36
Kerouac, Jack, 4
Kesey, Ken, 157
Kew Gardens (London), 51, 143
Kim, Jong-Il, viii, 59, 60
Korla Pandit (John Roland Redd), 119
Kozik, Franz, 39–40
KPFA radio, 19
Krafft, Charles Wing: artistic career of, v–viii, 4–9, 59–60, 129, 134–36, 148–49, 152–54; early life of, iii–iv, 1–3; heterodox interests of, viii–x, 48, 51, 58–59, 61–63, 73–81, 135–46, 143–145, 154–56, 157–60; last years of, xiii–xv, 69; political journey of,

x–xii, 47–48, 50–51, 62–63, 67, 72, 74, 77, 94, 141–42; public controversies, xii–xiii, 9–44, 47–49, 51, 61, 63–72, 81–83, 85–95, 98–125, 130–34, 140–41; works, vii–viii, xviii–xix, 7, 8, 37–39–40, 130, 136; on beauty, 22–23, 44; on being a "White Advocate," xi, 62–63, 67, 72, 74, 77, 121; on craftsmanship, 22–3, 44; on hobby crafts, 152–53, 159; on Modernism and Postmodernism, 8–10, 21–28, 59–60; works: Forgiveness, 37–39, 130; Disasterware, vi–vii, 7, 29, 52; Pitchfork Pals, 16, 130; snuggle bunnies, 39–40; Spone, viii, 7, 8, 136
Krishna Das, 17
"Kustom Kulture," 96
Kumbha Mela, v, 100, 132

L
Laguna Art Museum, 6
Laibach, vii, viii, 8–9, 11–12, 15–16, 21, 38, 54, 58, 135, 158–59
Lakeside School, iii
Larkin, Philip, 96
Lawrence, D. H., 19
Leary, Timothy, 157–58
Leavitt, Michael, 16, 157
Lee, Ivy, 155
Legion of the Archangel Michael, 14, 136–8

Lévy, Bernard-Henri, 97
Lewis, Wyndham, 24, 26, 114
Life Magazine, 6, 51
Lightning and the Sun, The, 32–33
Limbaugh, Rush, ix
Lincoln Memorial, 80
Ljubljana, viii, 8, 10, 58, 154
Lockhart, Sir Bruce, 51, 143
London Forum, xv, xvi, 129; London Forum speech, 129–45
Longley, James, 96
Lord Leighton, Sir Edward, 136
Los Angeles, 29, 38
Louvre Museum, 6
Lovecraft, H. P. *See* H. P. Lovecraft Prize, the
lowbrow art, iii, vi, 5–6, 15, 29, 31, 39, 105
LSD, 157

M
MacDonald, Kevin, 95
Maha Kumbha Mela, v, 100, 132
Mahler, Horst, 136, 139
Makers Exposition, 160
Malevich, Kazimir Severinovich, 10, 16, 54, 59–60
Manson, Charles, viii
Marinetti, Filippo, 24, 26, 114
Marlowe, Philip, 96
Martin Denny, 120
Marxism, xx, 12, 94, 125, 137, 144, 150, 159–60. *See also* cultural Marxism

Index

Maryland, 145
McKenna, Terrence, 157
McQueen, Steve, 4
Melbourne, 29
Mellon Foundation, the, 150
Memories and Reflections of an Aryan Woman, 35
Merry Pranksters, the, 157
Mickey Mouse, 10, 155
Middle East, the, 79
Mishima, Yukio, viii
Mjolnir Magazine, 98, 134
MKULTRA, 158
modernism, 10, 23–24, 26, 28, 59–60
More Artists of the Right, xx
Morgan, John B., xiv
Mothersbaugh, Mark, 30
Moynihan, Michael, 15
Munch, Edvard, 26
Munich, 27, 83
Mussolini, Benito, ix, 26
Mystic Sons of Charles Krafft, xv, xvi
Mystic Sons of Morris Graves, v, 8

N

Napoleon III, 136
Nation, The, 82
National Futurism, 24, 47–48. See also Futurism
National Public Radio (NPR) xii, 92–93, 101, 107
National Socialism, ix, 15, 26, 40, 48, 54, 55–58, 60–61, 65, 71, 80–82, 90, 93, 115, 128, 149
National Vanguard, 62, 71
nationalism, vii, 10, 12, 13, 19, 46, 48, 136
NATO, vii, 79
Nazis in America, 61
NEA (National Endowment for the Arts), 9
Near East, the, 43, 79
Neem Karoli Baba, 17
neofolk, xi, 15–16, 19, 50, 115, 158
Nerdrum, Odd, 20
Neue Slowenische Kunst (NSK), vii, 9–11, 39, 58–59, 159
Neumann, Franz, 144
New Collectivism, 11
New Delhi, 17, 34
New Right, xx, 12; artistic, 119; European, 12; North American, 19, 47; Romanian, 13
New School for Social Research, 144
New York, 3, 29, 37, 40, 58, 139, 147
New York Review of Books, 81
New York Times, The, 116, 124
New Yorker, The, xii, 89
New Zealand, 42, 43
Noordung (Cosmo-kinetic Cabinet Noordung), 11
Nordin, Ed, 16
Northwest China Painters Guild, iv, vi
Northwest Forum, xi, xv, 146
Northwest Front, 93
Northwest School, iii, v, 6
Norwegian Defense League,

57, 68
Not Banksy, 133
Nuremberg Trials, 51

O
O'Meara, James, xvi
O'Rourke, P. J., 121
Occidental Observer, 77, 156
occultism, ix, x, 115, 150
Open Society Foundation, vii
Order of the Nine Angels, 42
Osbourne, Ozzy, 15
OSS (Office of Strategic Services), 51, 144

P
Pacific Northwest, 7, 16, 150. See also Seattle
Paley, William S., 51
Panamerenko, Henri Van Herwege, 15
Pankhurst, Christopher, xix
Parfrey, Adam, ix, 32–33, 81, 119, 120
Paris, 24, 29, 105–106, 152
Pärt, Arvo, 96
Parton, Dolly, 147
Péguy, Charles, 97
Pepe the Frog, 149–50
Perdue, Judy, xvi
Perdue, Tito, xii, xvi
philosophy, v, 11, 21, 22, 38, 111
Picasso, Pablo, 23
Pierce, William Luther, 62
Polignano, Michael, xiv, xvi, 1
political correctness (PC),

xii, 9, 85, 103, 116
Pondicherry, 35–36
pop art, iii, vi, 10, 31, 71, 152
Pop Surrealism, vi, 31
porcelain, iv, vii–viii, 7–8, 38, 52, 129, 135. See also Delftware, Disasterware
Porcelain War Museum, viii, 8, 135
Portugal, 62, 118
postmodernism, 8, 10, 13, 21–22
Pound, Ezra, ix, xx, 19, 24, 50, 82
Predictions of Fire, 11
Proust Questionnaire, xvi, 96–97, 105–106
psychological warfare, 143–45
Puget Sound, v
Putin, Vladimir, viii
Puyallup Fair, 152, 153
PWE (Political Warfare Executive), 51

Q
Quinn, Cyan, xvi

R
Raimondo, Justin, 83
Ram Dass (Richard Alpert), v, 17
Ramana Maharshi, 34
Rammstein, 15–16, 19
Rampa, Lobsang, 17
RAND Corporation, 145
Rand, Ayn, viii
RE/Search, 119
Reagan, Ronald, 14, 138
Rebel News, 133

Rebel Press, 141
Reed, Douglas L., 96
Reid, Larry, 8
Rembrandt, 20
Republican Party Animal, 120
Republican Party Reptile, 120
"Retroavantgardism," 10, 58, 158
Revelation, Book of, 6
Ripley's Believe It or Not!, 8
Ritchie Boys, the, 144–45
Rite of Spring, The, 37
Robertson, Wilmot, 62, 68
Rock Garden, the (club), 3
Rockwell, George Lincoln, ix
Roerich, Nicolas, 37
Romania, x, 12–14, 48, 62, 79, 88, 136–39, 159
Rome, 29, 152
Roosevelt High School, iii
Roosevelt, Franklin Delano, 81
Roq La Rue Gallery, 39
Rosenberg, Harold, 155
Roth, Ed "Big Daddy," 6
Royal Academy of Arts, 136
Rudolf, Germar, 140
Russia, 10, 60, 75, 137, 159
Russian Constructivism, 10
Russian empire, 75
Russian revolution, 159
Ryden, Mark, 31

S
Saatchi Gallery, 156
Sacramento Museum, 106
Salon, vi, ix, 86
San Diego, 65
San Francisco, iv, 2–4, 29, 39, 54, 63, 119
Santa Monica, 30
Sarajevo, vii, 8, 12, 38–39, 135, 158
Sartre, Jean Paul, 22
SAS, 136
Satanism, 42
Savitri Devi, v, xx, 31–35
Scandinavia, 28, 153
Scott, Hadding, 77
Seattle, iii–v, vii, ix, xii, 1–3, 6, 8–9, 17, 19, 27, 29, 31, 47, 52, 54, 62, 69, 70, 85, 87, 96, 100, 123, 130–32, 146–50
Seattle art scene, vii, 131
Seattle Arts Council, 146
Seattle Times, 91
Serrano, Miguel, 33, 35
Shafrazi, Tony, 104
Shire, Billy, 29
Skagit River, iv
Skagit Valley, vii
Skagit Valley art scene, vii
Skagit Valley Community College, iv
skepticism, 62, 70, 74, 76–78, 91, 101
Slaughter, Kevin, xvi, xvii, xix
slavery, 75
Slick, Grace (née Wing), iii, 2, 30
Slick, Jerry, 2
Slovenia, vii, viii, 8–13, 58, 60–61, 135, 154, 158
Smith's Report, 140
Snyder, Gary, iv

Soap Plant, 29
Social Justice Warriors (SJWs), 134
socialism, 12, 134, 159
Socialist Realism, 58
Some Thoughts on Hitler, 41, 80
Soros, George, vii
South America, 151
Southern Poverty Law Center, 67, 68
Spitzweg, Carl, 26
Spode, Josiah, 134–35
Spone, viii, 7, 8, 136
Spotts, Fredrich, 26
Sri Aurobindo, 35
Starbucks, 152
Stein, Chris, 30
Steinberg, Leo, 155
Stephens, George, 51
StolenSpace Gallery, 129, 133
Stolz, Sylvia, 140
Stonor Saunders, Frances, 155
Stranger, The, xii, 61, 63, 66, 69–70, 77, 86, 98, 100, 102–103
street art. *See* lowbrow art
Strindberg, August, 28–29
Swami Shivananda, 18
swastikas, 38, 52–55, 58, 61–62, 65–66, 130, 160
Sweden, 28
Switzerland, xiv, 144
Symbolism (art movement), 27
symbolism & symbols, iv, 27, 38, 49, 54, 58, 60, 82; see also iconography

T
Takoma Records, 3
Third Eye, The, 17
The Mother. *See* Mirra Alfassa
Third Reich, 10, 26, 55–56, 66, 158. *See also* Hitler; National Socialism
Thoreau, Henry David, iv
Tibet, 17
Tibet, David, 33
Tibetan Buddhism, v, 15, 17, 18
Time, 51
Tiruvannamalai, v, 33–35
Tito, Josip Broz, 12
Tobey, Mark, v, 6–7
Toby Jugs, 60, 130
tole painting, 153
Top of the Pops, 151
Topham, Arthur, 141
Toronto Globe & Mail, 81
Traditionalism, 20
Trifa, Archbishop Valerian, xi, 15, 48, 61, 138
Trucker Fags in Denial, 96
Trump, Donald J., 146
Tugboat Annie, 97
Tumblr, 25
Turner, Jez, 129, 145

U
U.S. Holocaust Memorial Museum, 80
UN (United Nations), 110
underground comics, vi
underground film, 3
University of Washington, 17

V

Van Gogh, Vincent, 26
VE Day, xix, 145, 160
Vice Magazine, 89, 110, 132
Vietnam War, 157
Villa Delirium Delft Works, xv
Vinson, Irmin, 41, 80
Vishnu, 32, 36
Voltaire, 97
Von Dutch, iv, vi, ix, xv, 4–7, 15, 53
von Hoffmeister, Constantin, 24
von Keller, Albert, 27
von Max, Gabriel, 27–28
von Stuck, Franz, 27
Vorpal Gallery, 4
Vorticism, 26, 46, 114

W

Wacko, 29
Warhol, Andy, 146
Washington Monument, 80
Washington (state), 86, 141. *See also* Pacific Northwest, the; Seattle
Watts, Alan, v, 18–19
Way to the Labyrinth, The, 37
Weber, Mark, 139
Welk, Lawrence, 117
White advocacy, xi, 74
White Nationalism, xii, 57, 61–64, 67, 72, 74, 77–78, 87–90, 98–99, 101, 108, 113, 121, 130, 132, 133

White Rabbit Radio, 113
White supremacy, 54, 74, 88
Wilder, Billy, 51
Williams, Robert, 6
Winehouse, Amy, 156–57
World War I, 136, 151
World War II, x, 10, 13, 46, 59–61, 79–81, 83–84, 136–39, 143, 145
worldbeat, 16
Wynn, Keenan, 5

X

X-Men, 155

Y

Yeager, Carolyn, 77, 125
Yeats, William Butler, 19
Yockey, Francis Parker, xi, xiii, xvi
Yoga Vedanta Forest Academy, 18
yoga, v, 17–18
Yorkshire, David, 134
Yugoslavia, 12

Z

Zen Buddhism, iv, v, 6, 18, 29
zines, 114–15, 158
Žižek, Slavoj, 12, 159
Zündel, Ernst, 78, 143

About the Author

Charles Wing Krafft (September 19, 1947–June 12, 2020), "the dark angel of Seattle art," was an American painter and ceramicist, as well as a poet and essayist. Straddling the worlds of fine art and "lowbrow" art, Krafft began as a painter of the Northwest School but in the 1990s became famous for his dark and ironic Delft-style ceramics depicting weapons, disasters, and dictators, which were featured in galleries, museums, and exhibitions around the world. In the last fifteen years of his life, Krafft became an increasingly outspoken Holocaust revisionist and white advocate. He died in 2020 after a two-year battle with cancer.

www.ingramcontent.com/pod-product-compliance
Lightning Source LLC
Chambersburg PA
CBHW030937180526
45163CB00002B/607